Inshallah

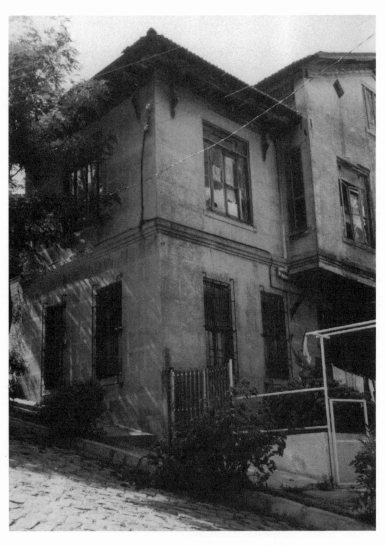

The house on Büyükada, Turkey

With best wishes,
Viviane Wayne
June 2002

Inshallah

In Pursuit of My Father's Youth

Viviane Wayne

FITHIAN PRESS, 2002
SANTA BARBARA, CALIFORNIA

Published by Fithian Press
A division of Daniel and Daniel, Publishers, Inc.
Post Office Box 1525
Santa Barbara, CA 93102
www.danielpublishing.com

LIBRARY OF CONGRESS CATALOGING-IN-PUBLICATION DATA
Wayne, Viviane, (date)
 Inshallah : in pursuit of my father's youth / by Viviane Wayne.
 p. cm.
 ISBN 1-56474-381-0 (pbk. : alk. paper)
 1. Wayne, Viviane, (date) 2. Sephardim—California—Biography.
3. Jews, Turkish—California—Biography. 4. Wayne, Viviane, (date)—
Journeys—Turkey. 5. Jews—Turkey—Biography. I. Title.
 F870.J5 W39 2002
 979.4'004924'0092—dc21
 2001001484

With loving gratitude to Ellis,
whose eagle's wings never faltered

and to Peter Clecak,
who insisted I try

and to Joseph Bell,
who taught me.

Contents

Inshallah

Turkish Overlay

TURKEY MEANT MY FATHER, whose past was buried there. Turkey was the omnipresence that overlay the life of my family—Sephardic Jews transplanted from Constantinople to Southern California.

Turkey meant my mother's recollections of childhood scenes during the last sultanic reign, that of the inept and barbaric Abdul Hamid II—dubbed "Abdul the Damned," which told it all—and of his harem. He was deposed in 1909. She was sixteen at the time, certainly old enough to remember. She described vividly, as though glimpsed only yesterday, the veiled women of the harem being paraded through the streets of Constantinople, protected and encircled by the "Black Eunuchs."

Different groups dressed in different costumes, my mother recalled, like the uniforms of individual racing clubs. The women, plucked from Asia and Africa for sultanic pleasures, were clad in opulent silks shot through with golden threads, on which lay elaborately jeweled necklaces. Their fingers were festooned with rings and their arms encircled with delicate bracelets that tinkled together, making a sound like the rattling of porcelain teacups.

My mother especially remembered her awed fascination with the gauzy veils that covered much of the women's faces: She strained to get a glimpse of the women's eyes, certain they were

windows into their hidden lives. But the women were too well protected by the eunuchs, who rushed them through the crowds, leaving in their wake the scent of attar of roses.

I was captivated by the Arabian Nights flavor of my mother's stories, although to my mind they were just that—stories. I remained a skeptic. She was a gifted storyteller, my mother, for whom the tale was all, but she'd been too long gone from Turkey. Distance and the ephemeral nature of memory had doubtless attenuated the facts, I thought. Many years later, long after she died, I read a color-laden, febrile description of exactly such a scene by Nikos Kazantzakis, and offered up a belated *mea culpa*.

Turkey meant floral, often threadbare, rugs that covered the wooden floors in my house, the objects of my first-generation disdain because they were not the bland, wall-to-wall carpets that floored the homes of my "American" friends. But when I watched my cousin Robert maneuver his toy autos, stretched out on those intricately designed rugs, his throat erupting with eight-year-old motor car noises—*vroom-vroom*—I sensed without understanding the wealth of their weavers' imaginations.

Turkey was culinary, as well. Our staples were *berenjenas* (eggplant fried or stewed), *arroz* (rice), and *keftes* (meat patties mixed with leeks or spinach, or sometimes wrapped in grape leaves). The olives we ate were not smooth and pitted and sold in cans, but were bathed in oil, inky-black, and wizened like the eyes of ancient Gypsies.

Our desserts leaned to custards sprinkled with rose water, and baked apples. Lemon meringue pie was never a consideration. Instead, we ate dried figs from Smyrna, Bulgarian yogurt, apricot paste, and Muscat grapes with feta cheese. I yearned for Velveeta.

Turkey equaled *inshallah*—God willing—a philosophical phrase that carried a far heavier weight than the French *Si Dieu*

veut, which seemed only a figure of speech, not a direct communication with God: Man's attempt to control his destiny, already determined by God, was a foolish and puny struggle. Better to meet one's fate with a shrug and gracious surrender.

An invisible but palpable gauze of fatality blanketed our lives, and while I don't remember ever giving it conscious thought, I subconsciously knew that this philosophy contrasted with the peculiarly American conceit that, with sufficient knowledge and effort, any problem could be solved.

So I accepted the canons of *inshallah* unquestioningly until I married an optimistic, pragmatic, non-Sephardic who informed me, with rosy assurance, that "we will live in Europe for a year," and, lo, we did! I became a convert based on the incontestable evidence that this American conceit brought results.

While I put fatalism aside as a quaint illusion, I never quite managed to give it a proper burial. At those infrequent times when it would pop up unexpectedly, and certainly it did, I felt torn: I couldn't reconcile the dichotomy.

Turkey meant interwoven Gallic threads. The French language and culture were introduced to Turkish Jews in the late 1860s by schools run by the Alliance Israelite Universelle, which sought integration within the various countries in which it operated. French was the language of literature and culture. But at the same time, Ladino—that language known as Judeo-Spanish, brought by the Sephardic Jews from Spain and Portugal and evolved over the centuries with regional variations—continued to be spoken regularly at home. It is a sweet tongue, with a nod to Portuguese.

After her schooling at the Alliance, my mother was sent to a Catholic school in Paris to complete her higher education. Those formative years in France transformed her into a crypto-Christian and a lifelong Francophile. From the time I was born until the

day she died, she spoke and read only French to me, despite being fluent in both English and Ladino.

I was weaned on *La Bibliothèque Rose*, eighteen books written by the Comtesse de Ségur to amuse her grandchildren. They were classic morality tales written by a titled woman of talent who embedded her sermons of good versus bad in plots of sufficient interest so that sixty years later I can still remember them vividly.

My father, although equally fluent in French, spoke only English to me. By the time I began school at age five I was bilingual, which made me feel both superior (I knew French and the others didn't!) and different—the ultimate sins. The result was a priggish little girl who refused to speak French to her mother who, with innate intelligence, continued to do so. I wonder if her wisdom was also partly the result of having grown up in a multilingual family.

The background of these Sephardic Jews is traceable to the Spain of Ferdinand and Isabella, at the height of the Inquisition in 1492. Jews were forced to convert to Christianity (becoming Marranos, Jews who practiced their Hebraic rites in secret), or were killed or compelled to flee to other lands, among them Turkey.

Sultan Beyazit II's Ottoman deliverance for the ousted came in the form of boats for transport to Turkey's newly conquered lands. The Iberian refugees, including Jews from Portugal, were dropped off in groups in Italy, Serbia, and the island of Rhodes, among other places, but most went to Constantinople, where they settled down to relative peace and safety. In Constantinople alone, almost 30,000 Iberian Jews found asylum.

The Jewish experience of the Christian world mirrored the Muslims' profound distrust of Christianity. As descendants of Abraham—and with their safety thus assured by Islam—the Jews were absorbed into the Ottoman empire rather than stifled. They were granted the right to pursue their religion and customs in

peace. Even while paying higher taxes than Turks, and despite isolated periods of harsh restriction, the Jews continued to be treated relatively well for some five hundred years.

That original sultanic welcome was not a completely altruistic gesture, although a later revisionist image was deliberately put forth to present it as such. The Jews were proficient in commerce; their skills were needed by the Ottomans, since commerce was not considered a suitable profession for the Muslims. In addition, the Jews brought a long and rich legacy in medicine, diplomacy, and printing.

Turkey became a new hub of the Jewish Diaspora, and remained so from the late 1500s until the early 1900s, when the wreckage of World War I, the Greco-Turkish War of 1920-22, the despotism of the last sultan, Abdul-Hamid, and better economic opportunities in other countries finally lured them elsewhere. The worldwide scattering of Jews to Mexico, France, South Africa, Cuba, Canada, South America, Australia, and the United States severely reduced the number of Jews in Turkey.

From these antecedents sprang both my mother's and father's families, who were born in Turkey, as were the generation before theirs and the one before that. Each family produced nine living children. Of the nine on my mother's side, the majority were highly intelligent and sensitive and lived lives of passionate exaggeration, devoted to their creative, sometimes neurotic, always idiosyncratic views of the world.

One of the more flamboyant members of that tribe was my mother's older brother Isaiah. Somewhere in his history of considerable success in business, he made a total political turnaround and embraced an idealistic form of Communism, which he celebrated one day by leaning over the balcony of his apartment in Paris and raining down piles of French francs in a grand gesture to the masses.

My father's side produced tamer natures. While respectful of the intellect, they tended to be pragmatic, bound by the family canon of loyalty to one another. Brothers took care of other brothers and sisters as a matter of course, without expectation of gratitude: in fact, if confronted with an instance of their generosity, they became embarrassed; it was simply what one did.

My father's younger brother Norman married my mother's younger sister Fortunée. Both family names were Fresco—simply a coincidence, they were always quick to point out: not even a hint of intermarriage, they stressed. My cousin Robert and I, of course, made a point of crossing our eyes and assuming poses of drooling idiocy whenever the subject came up.

These unions combined both family tendencies and resulted in lifelong friction between my mother's fragile, intellectual, and spiritual nature and my Aunt Fortunée's explosive, generous, and instinctive temperament. The effects of that friction, born of the sisters' self-proclaimed childhood identities, haunted them until their deaths. War was followed by armistice, which was followed by a period of peace, and, predictably, rumbles of a new war. The scenario, whose effects were felt by their husbands and children, was played out again and again.

One day, when my mother was close to seventy and her sister sixty, I witnessed an exchange between them in which my mother, her voice a strangulation of raw wounds, cried out, "But father loved you best!"

"But *you* were the good student!" shot back my aunt with equal fury.

My cousin Robert, Fortunée and Norman's only child, and I grew up together in mutual love and conspiratorial collusion against the adults, but with an unspoken agreement never to discuss the inflammable dynamics of the family. It was as though we were the only members of an arcane, secret society that some-

times amused, sometimes horrified us. "Are *all* families like this?" I remember thinking, exasperated and ashamed, yet entertained by my relatives' unbridled melodrama.

Within this small family we kept close track of relatives on both sides, who were scattered all over the globe. They were an oral part of my life, fleshed out and given substance by my mother's recollections (less my father's, who had come early to America) and connected to her stories by faded photographs.

On rare occasions an uncle or aunt from abroad came to California, an event of high consequence, acknowledged with all the pomp appropriate to a Papal visit. Such was the visit from my Uncle Mauricio, my mother's youngest brother. He had left Turkey at the age of seventeen, the most adventuresome of them all and, after wandering much of the world, settled in Mexico.

A vibrant, darkly handsome man with awesome energy, Uncle Mauricio swept into town about twice a year from exotic places—he had been the Mexican consul in Shanghai during the Manchurian War, later consul to Bordeaux during the Second World War. His visits were akin to some force of nature that blew like a gale through our bourgeois lives. For their entire duration, everything seemed underlined, abuzz.

His sisters, my mother and my Aunt Fortunée, adored and despaired of him. They savored his romances, like young girls exchanging racy novels in secret under the bedcovers, while my cousin and I shamelessly but unsuccessfully eavesdropped on their whispered tattle. They worried about his carefree jaunts around the world. Their husbands were openly envious and admiring.

During his travels, we would receive packages encrusted with foreign stamps. I remember one such from China that yielded up an emerald green silk dressing gown for my father and a series of pastel paintings, tender-hued as the throats of doves, for my

mother. On my sixth birthday, a small, round, hand-woven Chinese rug depicting the Aztec calendar arrived for me. I have it still.

Mauricio always stayed with my Aunt Fortunée. Her house was large, her larder filled to bursting with his favorite foods ("Extravagant!" proclaimed my mother over the imported papayas; "It's what he *likes!*" countered her sister) and their temperaments—explosive, generous, fueled by passion—were kindred ones.

At the sumptuous party Aunt Fortunée always gave in Mauricio's honor—which included, of course, an orgy of eating—he made a splendid exhibit. Bright, articulate, opinionated, traveled, and debonair, he inspired intimacy and trust in men and thinly veiled lust in women, whom he treated with a crackling romantic edge.

Predictably, on the day of Uncle Mauricio's departure there was the inevitable explosion with Fortunée, the result of his impatience and her trotting out ancient family conflicts yet one more time. It exasperated him beyond endurance. I heard her say, "He will never stay in this house again! *Au grand jamais!*" (Absolutely never!) In moments of high drama, French was always spoken. And I heard him say, "She is *impossible!* All emotion—no intellect!"

My aunt would sniff loudly and scrub the bathroom furiously to indicate how disruptive his presence had been, and he would cast his eyes skyward—a suitable subject for El Greco—but always with a side glance and wink to me. For I hung around. I watched him pack his monogrammed Egyptian cotton shirts, his shaving lotion, redolent of limes and something else, something exotic. I wished desperately that he would never go.

And then my father, the only driver in the family, would arrive in his Chevrolet and the entire tribe would pile in for the trip

to the airport, all arguments forgotten. My aunt would weep loudly at the sight of the plane parked on the tarmac. *Un joujou!* (A toy.)

She was absolutely convinced it would crash and Mauricio would plunge to a fiery death. He would laugh and hug us all, and we would watch him stride toward the airplane, his trenchcoat tossed casually over his shoulder…leaving an intoxicating whiff of freedom behind.

Uncle Mauricio hosted all our friends who went to Mexico. In return, his friends arrived at our doorstep in a steady parade— exquisitely tailored Mexican industrialists and their opulent wives, writers whose every word was cast in bronze ("after all, if Mauricio sent him…")—and were suitably feted.

Then one day, an event occurred that profoundly altered my life. Mauricio's former mistress, Nanette, appeared, a rosy, fortyish Gallic woman with an unquenchable joy of life, and was obligatorily entertained. Her outrageous flirting with Uncle Norman— an automatic reaction to any appreciative male—earned my aunt's tight-lipped disapproval. Nanette became a good friend to my mother, however, and some five years later introduced me to the man I would marry.

Nanette and Uncle Mauricio remained friends, even though she later moved back to France and married Constant, an aptly-named widower who was everything my uncle was not—gentle, steady, emotionally dependable. She once said to me, in describing my uncle, *"Un caractere affreux, mais.…"* (Terrible character, but.) Her eyes were dreamy.

And finally, Turkey meant the house on Büyükada. On the largest of the Prince's Islands, one and a half hours by ferry from Istanbul, stood the house that had originally belonged to my paternal grandparents. It had sheltered them, their children, and their grandchildren. What little I knew of it came from two

sources: a nostalgic description by my older cousin Sylvio, my father's nephew, sent there from Rhodes to attend school in Istanbul under the guidance of his grandfather; and a postcard received by my mother from Aunt Nouriye, my father's sister, who lived there year-round. The black-and-white postcard showed a body of land covered by forest, lying pacifically on the Sea of Marmara. I used to look at the photograph of rooftops embedded among the pines and try to imagine which was "our" house.

After she was widowed, my Grandmother Mercada lived in the house until she died in the late 1950s, then left it to her nine offspring. It was at that time that my mother, the widow of one of those nine inheritors, was informed she was now part-owner, and as such was required to register with the Turkish consulate to verify her credentials.

"When I die, that inheritance will go to you," Mother told me with the pride of one who, always lacking material goods, felt that she had something tangible, at last, to leave her only child. I appreciated her impulse, but at the time I thought it pure fantasy. I would probably never get to Turkey (*inshallah* raised its head) and so, for me, it remained another whimsical geographic fancy unanchored in reality.

Two years after our marriage, my husband and I went to Paris, where we met the French contingents of both families. Long before I knew them, and thanks to my mother's keen-edged descriptions, they were as real to me as characters in a book I had read over and over again. The uncles and aunts, for the most part people of good heart and good will, gathered us in with unconditional welcome. After all, we were family, were we not? *Mashallah!*— God be praised! The cousins were bonuses; they were highly amused by *"la cousine d'Amerique,"* with her casual California

ways and her young musician husband whose optimistic world-view seemed quintessentially American.

Their Turkish stories (echoes and elaborations of my mother's, although seen through the scrim of having lived for many years in France) fed my growing curiosity about Turkey, in particular about my father's early years. Why had he come to America, I wondered, while most of his siblings remained in Turkey?

I was fifteen when my father died, too young to perceive him as anything other than my rock of stability, the beloved presence who supplied uncritical love and humor. In my ego-centered world, it was enough that he simply existed for *me*. I began to ask questions about his early years only after his death, but many remained unanswered because my mother had scant information. And there were nine years difference in age between him and his brother Norman, so there existed lacunae about his older brother's history.

My parents had married within a month of meeting in Constantinople. The meeting had been engineered by their fathers, who knew and admired each other. After a traditional romantic honeymoon in Venice and Lake Como, they left immediately for New York.

"But what if you hadn't *liked* him? Would you have been *forced* to marry him?" I prodded my mother. Steeped in books that recognized only romantic love as valid, I was horrified by the idea of an arranged marriage.

"Of course not," my mother answered. "But I *did* like him."

I do believe she told the truth—she *did* like him—but what she failed to add was that she had been twenty-seven, dangerously on the cusp for a woman in those times and in that culture, far from a beauty, with diminishing marital prospects. Also, she was probably loathe to burden her beloved parents with an unmarried daughter.

My parents became engaged almost immediately after meeting. The only photograph I have of this brief but promising period in their life shows a slim, dark, young woman dressed with great elegance, flashing a radiant smile. She is sitting on the grass under a tree somewhere in the countryside. A short, compact man stands behind her, his hat at a rakish angle, a flower in his lapel, leaning on his cane in a posture of courtliness. The expression on his face is one of warmth and humor. Over the ensuing years, this look remained, and automatically drew people to him.

But the radiance of my mother's smile waned, and with it her expectations that the cloistered life she had known during her French schooling and within her family would continue. It did not. Life in New York was harsh, the weather inhospitable (the main reason for their later move to California), and the friends with whom to share her interests few. My father's earnings were scant. He was encouraged to move to Los Angeles by his younger brother, Fred, who lived there and held out the promise of kindlier weather and a Sephardic community that would welcome an insurance salesman.

My mother's smile was replaced by a mien of dignity, a shadow of sadness just below the surface. She created a home defined by order and aesthetics—and certainly love. But at her deepest level she retreated into intellectual and spiritual interests that found their most passionate expression in reading. She loved to tell the story of how, within a week of their arrival in New York, my father had taken her to the New York Central Library and urged her to check out some books.

"But, Ralph, they cost so much money!"

"No, no! They're free. Don't worry! You can take out as many as thirteen books at one time," he answered, whereupon she sat down right there on the lion-guarded steps of that great institution and wept for joy. For her, the streets of America were

paved not with gold, but with books, a luxury beyond her fondest dreams.

My mother was an avid reader with catholic tastes: Flaubert, Mauriac, Cervantes, Twain, George Eliot, Willa Cather, Dante. In her later years when I would visit her—she lived in a series of small, impeccably clean hotel-apartments—our verbal routine never varied. I would recount the latest adventures, successes, mischief in our daughters' lives, then I would ask, "What are you reading?"

She would recite aloud some passage that had moved her, from whichever book she was currently reading, and she read with such ardor that I never failed to respond. It became the strongest bond between us and the safest area of communication in a loving but troubled relationship that existed until several years before she died.

I never questioned that my mother's love of me was profound, but it ran parallel to her moral and spiritual bent, further ingrained by the Catholic nuns during her schooling in Paris. She felt that, since I was her daughter, my standards could be no less strict. They weren't. I was a lighthearted child, given to selfishness and undemanding of myself and others: I gravitated toward my father's sunny, unconditional affection.

That forty-year-old struggle between my mother and me carried over into unconscious levels of my mind and thence to dreams, where changes and a healing balm released me. Where did these come from? I still don't know. But I let go of my unreasonable expectations of what I wanted from my mother, which she could never give. In consequence, my newly softened attitude touched a chord in her, and for the first time she was able to show unqualified love for me.

During the last four years of her life, the love that flowed between us was blessedly untainted and expressed each time we

parted by her enveloping me in her strong, lean arms and utter-
ing, like a mantra, *"Que no me mancas nunca!"* (May I never be
without you!)

In 1977, after death had silenced my mother's tales, I began
to feel a compelling need to visit Turkey, this country 7,000 miles
away, larger than the state of Texas, which I understood imperfect-
ly by its parts, but not its whole. How had that country shaped my
parents? I thought I understood something of the forces that had
shaped my mother, but I knew almost nothing about my father's
early years. Was the philosophy of *inshallah* they had passed on to
me an inevitable byproduct of living in Turkey? And why had I so
readily accepted it? Might the house on Büyükada hold some an-
swers? And where was I in all this Turkish-French-American ad-
mixture?

My husband, always intrigued by my Sephardic tales, was en-
thusiastically supportive. "We'll simply go," he said. "You need to
see Turkey, meet your relatives."

A cousin, Emile, the son of my mother's oldest sister, Elise,
was still living in Istanbul. In addition, on my father's side there
was Aunt Nouriye, who lived in the family home on Büyükada,
plus Moise and Albert, the sons of his younger brother, Nevzat. I
felt confident that through them I could fill in the blank spaces in
the family tapestry.

I shelved all my other readings—a passion I inherited from
my mother—and instead began to concentrate on the history of
Turkey, swallowing whole an indigestible stew of horror and mag-
nificence. I read voraciously, both fascinated and confused, but
poised like an arrow to pierce its Asiatic heart.

In September of 1977, my husband and I boarded a plane
destined for Istanbul.

Istanbul Contradictions

"WE WILL BE ARRIVING in Istanbul in twenty minutes...."

The flight announcement was conveyed in a drone, as though this were an ordinary event. It was, of course, to the TWA crew who flew this route twice-weekly. Foolishly, I expected a slight catch, a verbal underline, in the announcer's voice, some indication that this was no quotidian destination. Certain place names carry a heavier weight than others: Mombassa, Kuala Lumpur, Borobadur, Istanbul.

Even subtracting my personal interest, the name Istanbul is freighted with layers of history, like an anatomy book that features transparent pages for different body systems that, laid one on top of another, produce the body's totality.

To my recent history-crammed mind, such was Istanbul: Byzantium, Constantinople, Justinian, the Seljuks, the Ottoman Empire, and finally the anomaly of the twentieth century superimposed on the architectural relics of the past in this, one of the world's great water cities.

We landed on this latest layer of the country where my parents and a long, unbroken line of generations before them had been born. Two dilapidated trucks lumbered up to a large shed and vomited out a planeload of bags onto the cement floor—a slag heap of luggage that we were forced to rummage in, around,

and beneath. Fourteen years later we were to land at this same airport and find it updated with all the usual aero-amenities—signs in various languages, cafes, souvenir shops, and a baggage section with mechanized rollways. But in 1977 that baggage section was nonexistent. The present chapter in Turkish history was one of escalating violence, of which we were not yet aware, but whose reverberations we felt for the first time on the bus going into the city.

One of our suitcases was missing. When my husband went to a small, dark bureau to complain, an infinitely bored man shoved a piece of paper through a slit in the dirty window and told him to fill it out and call tomorrow. The lost suitcase would probably come in on the morning flight, *inshallah*. If not, maybe the next day.

We ignored the large airline bus of ancient vintage in favor of the local transportation, a rattletrap city bus crammed with kerchiefed women and swarthy men on their way home from work. We boarded and held out our palms full of meaningless paper money; the driver took some and closed our hands over the rest with a horny paw. We bumped over pot-holed roads for twenty minutes.

At some point along the route, the driver stopped the bus and a lean young man wearing a soiled work uniform got on. He and the driver exchanged words we couldn't understand, but which became progressively louder and more threatening in tone. Then the young man stomped off the bus, snarling a muttered word over his shoulder. The driver slammed the automatic door shut and hurtled off in a cloud of dust. Then, apparently the victim of second thoughts, the driver stopped, backed up to where he had discharged the young man, put on his air brakes, and leaped off the bus. He grabbed the young man by his shirt collar and slammed his fist into the man's face. Blood spurted from the

young man's nose. The driver then leaped back onto his bus, re-
leased the brakes, and tore off down the road.

Horrified, we looked around. No one on the bus had moved
or uttered a word. They all sat impassively, looking neither left nor
right. And in this fashion we entered Istanbul.

I had chosen the Pera Palas Hotel for the two weeks we were to
stay in Istanbul, partly because the idea of staying in a modern
hotel seemed inappropriate in this most ancient of cities, partly
because of sentimentality. Whenever the name of my mother's
legendary older sister was evoked, I'd been told, "Your Tante Elise
stayed at the Pera Palas on her honeymoon," which implied the
ultimate seal of approval, since this aunt's royalist appetites were
reputed to be mythic.

This great Edwardian caravansary was perched astride a hill
in Beyoğlu, in the old Pera quarter, so as to better view its watery
realm. It had been built by the Orient Express Company as a suit-
ably luxurious stopping place for its railway customers, and had
been thus designed to imperial proportions. In our room, the ceil-
ing-high armoire's sole apparent purpose was to hold ball gowns.
The adjacent white-tiled bathroom held an enormous bathtub
raised on lions' claws.

Despite forty-watt bulbs in the bedside lamps covered with
rosy-hued silken shades, and a filigreed turn-of-the-century eleva-
tor cage that descended to the vast public rooms at the pace of an
arthritic duchess, this once-majestic hotel still managed to main-
tain a frayed dignity. I never found out whether the views from all
the rooms were so privileged, but the one from ours was both daz-
zling and somehow frightening in its complexity.

Across the confluence of three waters, the Bosphorus, the Sea
of Marmara, and the Golden Horn, a continual swoop of scream-
ing gulls looped and dove—according to legend, the ghosts of

women drowned in the Bosphorus. An improbable skyline was
pasted with the silhouettes of the three great mosques on the old
Stamboul side: The Aya Sofia, the Sulemaniye, and the Sultan-
ahmet. Their exclamatory minarets stabbed a leaden sky made
hazier yet by the roiling smoke from a dizzying number of ships of
all sizes that plied the choppy waters. The Galata Bridge, pendu-
lous with human traffic, connected the European side to old
Stamboul...layers and layers of history too dense to penetrate.

I was overwhelmed! How could I possibly hope to compre-
hend the heart of this Byzantine/Ottoman enigma, let alone sep-
arate the myriad parts that had informed my family's psyche? I
knew, of course, that no convenient pattern was going to reveal
itself at first sight. But this Constantinople-Istanbul was *old* and
accreted beyond my knowing where to begin. I stared at the scene
in a daze.

My husband pulled away from the window first, determined
to deal with practicalities. The missing suitcase contained his
shaving equipment, and he needed a shave. We went out into the
neighborhood in search of a barber shop. Fronting the Pera Palas
was Istiklâl Caddesi, the main street formerly known as La Grand
Rue de Pera, which eventually widened into a people-clotted
artery.

It was bisected further on by the Passage of Flowers, which ev-
ery night played host to a flock of gyro-eaters, beer and raki drink-
ers loudly declaiming poetry, and saz-players sawing their wailing
tones above the din. But directly in front of our hotel, Istiklâl was
a narrow, dilapidated street with a quasi-modern hotel across the
way and formerly elegant embassies, now reduced to consulates,
down the block. Scattered between these were a number of small,
dark shops.

Next to a store choked with beaten copper pots of every size
suspended from hooks in the ceiling, "hubble-bubble" water

pipes, coffee urns, and a jumble of Meerschaum pipes, was a bar-
ber shop illuminated by a single florescent light inside. A solitary
man sat beside two barber chairs, reading a magazine. We stood
looking at him for a long while, then my husband said, "After all,
a shave is a shave is a shave," and strode inside before he could
change his mind.

I positioned myself against a wall across the street and
watched. The barber, seeing a live one enter, leaped up from his
chair. With a balletic movement, he threw a dazzling white drape
over my husband, pushed him into the chair, and cranked it up
before he could bolt.

My husband gestured his desire for a shave; the barber nod-
ded. Then he tilted the chair back and I watched a silent rendi-
tion of "Figaro"—moist towels, bursts of steam, the barber strop-
ping his razor with relish. My husband's face disappeared behind
great gobs of lather. The barber attacked it with the brio of an Ital-
ian opera conductor.

Then he sat him up, rosy from the steam, rubbed his head
with something taken from a jar, and parted his hair in the mid-
dle. I saw my husband stare into the mirror as though hypnotized
by a snake. The barber, now in the fullness of his art, dusted him
with powder—pouf!—and in a great circular movement sprayed
him all over with a silver atomizer.

The barber stood behind my husband, his hands on my hus-
band's shoulder, his face directly above, and gazed into the mirror
with a smile that begged appreciation. My husband nodded,
dazed. The barber whipped off the drape, took the money prof-
fered, and bowed to his customer, now a pomaded, perfumed
Anglo-Turk who looked uncannily like my Turkish Uncle
Norman.

It went through my mind that, tonsorially at least, he was
ready to face Istanbul—and my family.

•

On my maternal side, one cousin remained in Istanbul: Emile. His mother, Elise, was my mother's older sister. I called from the Pera Palas and asked to speak to him. His wife Jenny, a physician, answered. She was polite but cool.

"Who is calling?"

"This is Viviane, Emile's cousin from America."

"Ah, Viviane!" Her voice brightened immediately. "Unfortunately, Emile is in Ankara on business. I'll call him immediately so he can catch the next train to Istanbul. But *I'll* come over straight away—where are you staying?" I told her.

"Bravo…what a good choice! I'll be there in a half-hour. We'll have some coffee together." She was about to hang up when I asked, "How will I know you?"

"I'll be wearing boots!"

We positioned ourselves in the bar, backed by beveled mirrors that reflected the roseate marble opulence of the Ottoman lobby, and waited. Exactly a half-hour later, a shaft of sunshine lit up the room. In her early sixties and looking easily ten years younger, with a great head of golden hair, cerulean eyes, and an incandescent smile, a booted Jenny strode over to the bar and enveloped us both in a great bear hug. I loved her instantly.

She sat down and plunged in. What did we do in life? How many children did we have? What sorts of people were they? Why were we in Turkey, and what did we want to see? Were we passionate readers; had we ever read the Russians? Yes, we had. Had she?

"Oh, yes. I read them first in French and thought they must be even more wonderful in Russian," she told us. "So I learned Russian. And they *were!*"

And could we come for dinner that night? The questions and answers tumbled out in arpeggios. When she left an hour later, we were irrevocably hers.

That evening we were met at the door by Emile. He was a small, neat man with even features. By his genuinely modest demeanor I would never have guessed he enjoyed an impeccable reputation as an international lawyer. "The image of his father, Gad. The same sweet nature," I'd been told by the family in Paris. "He is brilliant, and completely unpretentious." They were right.

Our dialogue continued as though it had never been interrupted, in their spacious apartment strewn with Oriental carpets—"I can't stand them, but Emile loves them"—a solid wall of shelves containing French, Turkish, Russian, and Spanish books and objects gathered during their travels. It continued as we drove along the Bosphorus to a restaurant that served *meze*, Greek-Turkish appetizers.

At the restaurant our waiter brought dish after dish—twenty, at least. All were delicious, all vaguely familiar to me yet foreign in their tantalizing combinations—raisins, peppers, coriander, pistachios, cardamom, sesame butter. I recognized in these flavors distant relatives of foods I had eaten all my life. It was a cuisine that originated in Spain, and was later informed by Greece, Syria, Lebanon, and Turkey, resulting in what I knew as Sephardic cooking. And after each dish, we threw back our heads and bolted down another round of raki!

We returned to Emile and Jenny's apartment to pore over family albums of photographs. Here, finally, were the faces that belonged to the names I had heard in my childhood. Here was a young Emile, and his sister Daisy. It was like watching the emergence of photographs from their silver nitrate bath.

"Ahh...so *that's* her!" I cried, seeing Tante Elise, then Uncle Gad and my cousin Yvette for the first time.

"Oh, this photograph reminds me of...!" exclaimed Jenny, and she was off on some spirited anecdote that fleshed out family

legend. I remember thinking later that night, as I lay wrapped in the Pera's down comforter and the family's warm cocoon of welcome, that once Emile met Jenny, all other women must have paled for him. The two had opened up the ancestral sluice, and I happily dove into those waters, eager for more stories, more details.

The following morning I telephoned the paternal side, my cousins Moise and Albert. They were the sons of Uncle Nevzat, my father's younger brother, who had come to California when I was about eight. Two memories remained from his visit.

First were the Lucullan feasts in his honor produced by my Aunt Fortunée. And then I recall the astonishing fact that during this entire visit the menfolk did not go to work. They undoubtedly wanted to spend as much time as possible with their Istanbullu brother; this would probably be the last time they would see him, for the idea of their going to Turkey was in the realm of fantasy. Seeing my father at home during the week turned my young world upside down!

I still have a book of photographs celebrating the visit from this uncle—a slim man with an elegant bearing and a small mustache, whose accent and suits were tailored in England, where he had lived for several years. At the time I didn't know the word *debonair*, but I instinctively felt there was a different tone to him than that found in my beloved but quotidian father and Uncle Norman.

When I called, Moise's wife Dolly answered the phone. "Viviane? Uncle Ralph's daughter? Oh, I can't wait to meet you!" Her voice was slow and melodious. "It's such a pity—Moise is in London, so you'll miss him. But Albert—Berto—is staying with us and you *must* come for dinner tonight. The children will be here. You will, won't you? Albert will come to the hotel this evening and pick you up. What are you doing this morning?"

"We thought we would visit the Bazaar."

"Good. You like *arroz*? And *borekas*? We'll have a simple family meal. Nothing elaborate. Until tonight, then."

Plunged into Stamboul

EARLY THAT MORNING we plunged into Stamboul, the original Byzantium, the old city across from "western" Istanbul that sprawled over the hills and tumbled into the water. Near the hotel a rackety underground funicular, the Tunel, dove six hundred yards down onto the tip of the Golden Horn, the brackish inlet fed by the Bosphorus, and disgorged its passengers at the foot of the Galata Bridge, a metal drawbridge suspended on huge pontoons, which must be counted as one of the great conveyors of humanity.

Stevedores, deckhands, businessmen in somber suits, uniformed schoolchildren carrying satchels, *hammallar* (human porters with leather humps strapped to their backs, bent double under donkey-loads of furniture), middle-aged men holding hands, kerchiefed women dressed in drab black or brown, scowling, mustachioed peasants holding tethered goats—all elbowed and surged in a continual progression back and forth across the bridge.

Then why did I have a vague sense of foreboding? Was it the grim miens on Turkic faces? An absence of color? Perhaps the presence of military police, impassive but armed, surveying the scene? There was a certain energy here; no one sauntered idly. But the general demeanor was dogged, stolid, unsmiling—and

somehow sinister. The whole massive human movement seemed fueled by some negative power.

That inexorable flow propelled us into Eminönü, the business district of old Stamboul, with its squat landmark, the ugly but imperial Yeni Camii or New Mosque. The end product of uninspired architectural vision, it was without a definitive signature; yet what it lacked in distinction it made up for in location. Froglike, it stared out at the Golden Horn, bordered inland by the Egyptian Spice Market and, to one side of a large square, a plant nursery redolent of potting soil. For sale were pots of gardenias, rhododendrons, bougainvillaea, jasmine—all plants for a felicitous climate. These were the same plants my mother, an ardent gardener, had nurtured 7,000 miles away in southern California. It surprised me: Istanbul is much farther north than Los Angeles, yet these plants seemed to fare well here.

Also in this ample space was a sprawling outdoor tea garden and an aviary filled with singing canaries and *bülbüller* (nightingales). One of my mother's favorite family stories was about her brother Isaac, "the sensitive one," in a family amply endowed with sensitivity. As a young boy, unable to tolerate the thought of any living creature in a state of imprisonment, he purchased all the caged birds his money could buy, then released them to the elements. The birds, having been raised in cages and fed regularly, flew away and died—of starvation, I imagine. And certainly fear. But his principles were applauded.

Many years later, after fighting alongside the Republicans in the Spanish Civil War and while still relatively young, Isaac became a Theosophist. He bought a small house in Vence, in the hills of southern France. Eventually, in accordance with some deeply held belief, or maybe following the dictates of his tenuous nature, he positioned himself beneath a tree in front of his home and starved himself to death.

On the south side of the Yeni Camii was a vast plaza populat-
ed by a dozen old men and women with wizened faces like apple
dolls, who sat on the steps of the mosque. They patiently held out
brass and copper pans overflowing with seed, which the tourists
bought to feed a confederacy of fat pigeons that carpeted the
ground with their spattered droppings and ceaseless *coo-coo-coos*.

We found a table at the outdoor tea garden and settled down
to observe the activities. Young and old men, squatting on steps
behind the mosque, had removed their shoes and stockings and
were washing their feet in stone basins of water before entering.
Their ritualistic movements, executed in slow motion, seemed
exercises in piety.

Across the way, a row of tidy but shabbily dressed men sat at
wobbly tables, pecking away on ancient typewriters. (It appeared
to me that nothing mechanical was new in Stamboul. The disrep-
utable fleet of bleating taxis that cruised the city was composed
mostly of large-finned, dented De Sotos with pirated parts whose
vintage disappeared into history.) For a few miserable liras, these
men—scribes—wrote letters for those who couldn't write, and
filled out forms for those who couldn't read.

Most of the patrons in this outdoor café were older men who
sat together wrapped in a blue haze of cigarette smoke, stirring
their tea. They spoke only occasionally, and then in low voices. A
few women sat together at other tables—friends having coffee to-
gether? Rarer still was there a mixture of sexes. There were no
children or students to enliven the scene. A somber collection of
people, I thought.

While we were watching them, a young boy, about twelve
years old, suddenly appeared at our table—we hadn't seen him
approach. He carried an elaborate shoeshine box containing
brushes, cloth, and jars of polish. It was decorated with silver and
copper and great brass nails, and garish paintings of fleshy harem

beauties lolling about on fringed pillows, playing with miniature monkeys. The whole astonishing thing was studded with fake rubies and emeralds like a cheap replica of the sultanic marvels in the Topkapi Saray.

The boy promptly fell at my feet in abject supplication. "Shine shoes, lady! Little money! I make shoes beautiful!"

No matter that my shoes were made of suede. Armed with the Turkish word for 'no,' I shook my head and said firmly, *"Hayir!"*

Rather than discourage him, my *hayir* impelled him to further heights of rhetoric. "You see! I make shoes clean—you happy lady! Please…only little lira!"

It was clear he was not going to go away. I shook my head like a pendulum gone berserk. *"Hayir! Hayir!"*

He hunkered down further on the ground and began to whine.

"Pleeze! Pleeze!"

My husband stood up, leaned over, and from somewhere inside the depth of his diaphragm, summoned up a baritone *"Hayir!"* worthy of Boris Goudanov. The boy stared at him in dread, as though witnessing a fire-breathing dragon, but didn't move.

Then, from the next table, a middle-aged man wearing a business suit and cracked black shoes rose and approached our table. He leaned over the crouching boy, muttered something to him in a low, menacing voice. The boy shrugged, rose, and walked away with his shoeshine box.

The man turned to us, bowed deeply, then extended his hand and said in good but accented English:

"My name is Mister Gülim, Dürsan Gülim, *efendi*. I beg your pardon for my young countryman. He tries to make a living, you understand, but sometimes he does not know when to stop. You are not offended, madam?"

My husband pulled out a chair, gestured to the waiter to bring another glass of tea, then motioned for the man to sit down.

"No, I'm not offended, but *hayir* doesn't seem to work…"

"Ah," said Mr. Gülim. "You must learn to use the word '*yok.*' It is much stronger than a simple *hayir*. When you say to a Turk '*yok!*' then he understands there is absolutely no appeal."

As though continuing a former conversation left dangling by time, Mr. Gülim chatted on in a warm and personal manner about Istanbul, the city of his birth. What had we seen so far? Nothing? Really? Tsk, tsk, tsk. What did we want to see? Everything! Ah! Three more leisurely teas were sipped.

"Then you have not been to the Misir Carşisi—the Egyptian Market—of course," Mr. Gülim continued. "Just by your nose alone you could find it, but I beg you to permit me to take you there." Where had he learned to inflect his English prose with such poetry? His caramel eyes rolled heavenward as he blew a kiss to the sky. My husband and I looked at each other. The Grand Bazaar could wait. We rose and followed Mr. Gülim, innocents abroad.

Under stone arches at one end of a covered bazaar, we entered a seemingly endless system of passages containing a virtual city of small shops where men beckoned us to buy used Emerson radios, ceramic plates imprinted with *Souvenir of Istanbul* above decals of the Aya Sofia, brocaded slippers with rubber soles, and used watches displayed on dusty velvet pillows.

Beyond these, the *baharatçilar* (spice sellers) lured us from the depths of their dark cubbyholes with exotic aromas emanating from huge barrels and bulging burlap bags filled with cinnamon, thyme, saffron, caraway, marigold petals, henna, cardamom, frankincense, myrrh—the scene lacked only three wise men loading up sacks with herbs and powders for their camel-trek to Bethlehem.

Mr. Gülim led us to stalls filled with jars of honey from the Taurus Mountains, dried figs and apricots, dates of every kind and *loukum*, which I recognized from my childhood as "turkish delight," a jellied candy dusted with powdered sugar. These treats were arranged on huge copper platters in designs as intricate as the famed Iznik tiles.

We succumbed to a display of pistachios, their hard shells partially open, inviting us to taste the green delights within. We bought a bag and leisurely munched away on them as we zigzagged from one booth to another, stopping here for yet another tea, there for rice pudding studded with swollen golden currants.

I paused in front of one shop, puzzled by the contents of the jars that lined the shelves. I noticed that Mr. Gülim hung back, his face turned discretely in the opposite direction. A corpulent man with a varicose nose, wearing a black leather apron, approached me with a knowing smile.

"Aphrodisiacs for woman. Aphrodisiacs for man. One spoon, lady. You take, he take—no problem." He winked and threw back his head and roared with laughter, the first full-throated laugh I'd heard from a Turk.

I walked over to his neighboring competitor, who rooted about in a malodorous shop that displayed snake skins purported to drive off unwanted spirits when burned as incense. Intimations of sorcery permeated this section of the bazaar. Suddenly, I felt swallowed up by apprehension.

My face must have given me away, because the ever-perceptive Mr. Gülim quickly introduced another venue. He had a cousin who had a shop "very nearby" that specialized in Turkish rugs—beautiful Turkish rugs—and he especially liked to meet Americans. Mr. Gülim himself had a friend from California, as a matter of fact.

"Fresno. He lives in Fresno. That is near you?"

He opened up a wallet distended with business cards and there, indeed, was a card from his "friend," one Mr. Robert "Bob" Wilcox, who sold electronic parts in Fresno. Friend—that word was bandied about so easily. What exactly did it mean to Mr. Gülim? Was it "friendship" and all that it entailed, or was it entirely mercantile at base, its authenticity sealed by a business card?

Immediately we became cautious. "We are not in the market for a rug, Mr. Gülim...."

"Oh, of course not, of course not! That is not important. My cousin is just happy to talk to Americans."

The cousin's shop was off a cobbled road behind the Blue Mosque, bordered by an ancient wall of crumbled grandeur in an area of ruined wooden houses several stories high. During my mother's youth, most houses were built of wood and fire was a constant peril in Constantinople. Twice her family's large wooden home almost burned to the ground; twice, they were forced to move. But despite the foul-smelling squalor, a boisterous peasant village was at work here, as though transplanted complete from central Anatolia. Women cooked over outdoor braziers, chickens scratched in the dirt, gray laundry hung across lines, shouting children chased each other through trickles of stagnant water. I noted a goat, as well as an absence of dogs.

My mother had a vivid memory of a time in her childhood when wild dogs so overran Constantinople that they were rounded up and taken to an uninhabited island in the Sea of Marmara and abandoned there without food or water. In time, with no other recourse, they ate each other. Their anguished cries, ululating across the water, became fainter and fainter until at last they were heard no more.

That horrible auricular memory never left her. Despite the mild, thoroughly domesticated dogs she was exposed to in my

household, she never felt comfortable with those animals. I came to the conclusion that most Turks—at least of that generation—distrusted dogs (an attitude shared by my family in France; no canine ever crossed their thresholds).

The carpet shop, two blocks away, was dark. But someone must have seen us approach, because suddenly a light went on inside, illuminating a pile of rugs in the window. When we entered, three heavyset men rose with amazing agility from pillows strewn across the floor, bowed, and motioned for us to sit down.

Mr. Gülim introduced us to his cousin, a sleek young man with an excess of black hair beginning low on his forehead. He clapped his hands.

"*Kahve!*" (Coffee.)

A weedy boy appeared from behind a drape.

"*As şekerli?*" (Slightly sweet) "*Şekerli?*" (Very sweet) he asked us, paused for the answer, then disappeared.

The three men settled themselves back down onto their pillows, leaned forward, and introduced themselves. Then they and the cousin began to ask questions in tones of solemn formality. We were in a theater of commerce, the first act of which, apparently, consisted of asking personal questions. Where were we from? "Ah, California!"

A discussion ensued about California's importance as the home of motion pictures—Movies! Hollywood! John Wayne! Rita Hayworth!—its geographical beauties, its ideal weather, its earthquakes. We reminded them, delicately, that Turkey was no stranger to seismic phenomena. They agreed. Devastating earthquakes in Turkey were compared to equally horrible ones in California.

Out came identically swollen wallets with business cards from "friends" in California. They would be honored to include my husband's card. An imperceptible shadow of disappointment

crossed their faces when he told them he did not have one, that he was a professor, and members of that arcane society rarely carried cards, whereupon all the men lowered their eyes in respect to this honorable profession.

With how many children had Allah blessed us, and what where their sexes? Ahh, what a joy to have three girls! *Mashallah!* Daughters always stay close to home.

But no boys? They glanced at me under heavy lids—doubtless it was my fault—and shook their heads sadly. We sipped our tiny cups of coffee and exchanged personal information for close to an hour.

Then suddenly, on a cue known only to the cousin, there was an apparition: A sepulchral-looking young man slithered out from behind that same drape in the back of the shop and flung down a huge carpet fit for palace floors, a silken, shimmering rectangle of infinitely subtle hues and intricate design.

"Ah!" we murmured in genuine admiration. Another carpet was flung down on top of it, leaving a tantalizing glimpse of the one beneath, and then another and another, until we were surrounded by a vast mound of woven gardens.

I felt powerfully seduced, and by his gaze of intense concentration, I could see that my husband was too. In my mind I placed one of those ravishing beauties on the floor of our living room. Would it fit, I wondered? Then the cousin murmured the price, as though it was a negligible piece of information. We both became extremely nervous.

"As we told you," my husband reminded Mr. Gülim, "we are not in the market for—"

"Tsk, tsk, tsk," clucked Mr. Gülim. "You must not feel obliged." And of course we did, which led us to an excess of sycophantic thanks. We rose and thanked the group for their courtesy. We thanked Mr. Gülim effusively for his kind guidance through

the spice bazaar. We thanked the cousin for showing us his beautiful carpets.

Then we hurtled out of the store, practically running down the street and back around the ancient wall. I can't speak for my husband's motives, but I was pursued by a familiar demon I knew I would eventually have to face—the shadow of my suppressed fatalism.

Someday, inevitably, I would have to buy a Turkish rug. I had no choice. My ancestry demanded it. And to shore up this total abandonment of will, I told myself that my paternal family—the children of Uncle Nevzat, one of my father's younger brothers—whom we were to visit that evening, would certainly agree.

Paternal Stories

MY MEMORIES OF Uncle Nevzat remained exceptionally clear. Aside from his California visit when I was a child, he had surfaced once again in my life when my husband I were living in Munich in the mid-1950s. I had received a telegram from Paris, where he and his wife, Esther, were visiting his sister Kamer.

"In Paris. Stopping in Munich on way back to Istanbul. Please arrange three-day stay good hotel central location. Look forward to meeting your estimable husband. Uncle Nevzat."

The estimable husband was intrigued. "What interests him? What do you think he might like?"

I trotted out whatever I could recall about Uncle Nevzat. He had been given an English education, he was a natty dresser, more than a bit of a charmer, and his drink of choice was Scotch. (How did I know that?) Of Aunt Esther I knew nothing. I made suitable hotel reservations and bought a bottle of Scotch.

We picked them up at the train station, three days later: To my mind Uncle Nevzat had barely changed. The few gray hairs now around his temples merely made him look more distinguished. His suits and shirts clearly came from Savile Row. His English was impeccable, with just a trace of a foreign accent, and his manners were informed by Old-World courtesy.

My husband asked him what he did.

"Ah, my dear…import, export…a little of this, a little of that."

A little of what, we wondered? He told us, vaguely and somewhat reluctantly, that "among other things, I import smoked eel from the Netherlands to Turkey."

Aunt Esther was his consort battleship. A large woman with a helmet of wavy silver hair and the most extraordinary green eyes — "Circassian eyes," murmured Uncle Nevzat, gazing deeply into them — she sailed beside him into our apartment, quickly scanned the room for the most comfortable chair, and proclaimed it her territory, whence she reigned benignly during the entire visit.

The proposed three days lengthened into a full week. They enjoyed being with us. They enjoyed meeting our friends. They enjoyed Munich. They enjoyed our children. And the bottle of Scotch grew from one to five. And we enjoyed them both. His charm was more than sartorial, and his interests were sophisticated. She was the epitome of a woman cherished by her family, whose household was her realm.

My husband took Uncle Nevzat to museums and for a tour of the city, while I took Aunt Esther shopping. She was determined to buy a dress in Germany, a country in which she wasn't in the least bit interested and whose language she disdained. I didn't think she would find anything to her liking and told her so. It would be a fool's errand.

But she was not to be denied, so I took her to the largest department store in downtown Munich and began the negotiations in German. My aunt simply stepped in front of me and, in French, asked the startled saleswoman to show her *everything* she deemed suitable. I felt that whatever hard-won dominion over my life I had achieved had been instantly eradicated by this force of nature. I fell back.

The saleswoman, cowed by Esther's imperious manner,

obeyed without question. Aunt Esther stripped down to her slip, deposited herself on a chair in a large dressing room, and sat patiently while the perspiring saleswoman brought out dress after dress, hour after hour.

Aunt Esther rejected them all out of hand, with the disdain of Catherine the Great banishing a supplicating courtier. Finally, the saleswoman brought out a black-and-white polka-dotted silk dress. Absolutely not, I thought. It's all wrong.

"*Non,*" I said.

"*Oui,*" proclaimed Aunt Esther.

She put it on. She was right; it suited her perfectly. Wearing her new German dress, she peeled out the requisite Deutschmarks and cruised out of the store looking for all the world like a splendid figurehead on the prow of a cutter.

One evening Uncle Nevzat contacted a young American couple whom he had met when they lived in Istanbul while working for the Voice of America. Now living in Munich, they invited us all over for dinner. Uncle Nevzat told one fine tale after another, in English, of course, while Aunt Esther, who had managed to commandeer the best chair in the house, nodded and smiled at the proper places in his dialogue.

I looked at her in amazement. I knew she didn't speak a word of English, only Turkish, French, and Ladino, yet her responses were entirely appropriate. Later, I asked her, "How did you know what was being said?"

"I didn't, my dear. But after many years one learns, you know, when to respond."

"Weren't you bored, just sitting there? What were you thinking all evening?"

"I was thinking about what we were going to eat."

Before they left, Uncle Nevzat begged us to come to Turkey. "Your grandmother Mercada is still alive, you know. She is in her

nineties, *mashallah*. It would thrill her to see Ralph's daughter. And I will show you the wonders of Istanbul!"

But we were absorbed in our work and the raising of three daughters, under the youthful assumption that time was elastic, if not endless. Perhaps next year, or the year after. Two years later my grandmother died. We returned to America never having met her. I recall feeling a dark pang of remorse and the recognition that life didn't necessarily adhere to my schedule. Turkey continued to remain an improbable dream.

Now, more than twenty years later, with both Nevzat and Esther long since gone, we were sitting in the living room of their son Moise's home, in the midst of his family. We were told he had gone to London to establish a commercial base and a home there; he had been doing business in the electronics field in England for years. The plan was for his wife and children to join him when he was finally settled.

And when would that be?

"Whenever it happens, *inshallah*."

Dolly, Moise's wife, had startlingly blue eyes and a seraphic gaze that perfectly reflected her candor. She reminded me of the beautiful French actress Michelle Morgan. That candor was matched by an ingenuousness that made her the inevitable target of the family's teasing. It was a different household from that of Emile and Jenny's—more connected to old Sephardic ways and made noisy and active by the presence of her children, Nevzat, Jr., and Terri. Both children were extremely good-looking. He was in his early twenties, she in her late teens. Both were at the threshold of their adult lives, unsure of their directions. They were impatient with themselves, and thus, as since time immemorial, transferred their frustration to their uncomprehending mother.

With us they were engagingly open and curious. How old

were *our* children? How did *we* raise our children, how much freedom did we allow them, they wanted to know, clearly hoping we would give them ammunition for their attempts at independence.

Moise's younger brother Albert, or "Berto"—a handsome youngish man with prematurely gray hair and the extraordinary "Circassian" eyes inherited from his mother, assumed the role of head of the household in Moise's absence, as well as that of an unabashed confederate of the children. Dolly didn't stand a chance against that troika!

After that initial evening, Berto and Dolly took us to a series of extravagant restaurants that augmented our girth and knowledge of Turkish cuisine. We began the meal with *raki*. Always. By the end of our trip I had become an enthusiastic convert to that anise-flavored drink, a close relative of the French Pernod.

I was familiar with *raki*, known as *arrak*, in the Levant. In the opinion of my father's mustachioed younger brother Norman, the daily necessities for prolonging life were a slice of dark bread, half a raw onion, and a glass of *raki*, all three of which he consumed with religious regularity before dinner. I watched him with interest.

Once, in my teens, I gave in to my curiosity and surreptitiously bolted down a shotglass of *raki*, as I had so often seen Uncle Norman do. After I caught my breath, I was terrified I'd drunk something akin to cleaning fluid!

But later, it occurred to me that perhaps Uncle Norman had been right. Woolly thinking led me farther down a crooked path—all of those foods contained healthful properties, and he *had*, after all, lived a long and active life, *mashallah*! Therefore....

That night Dolly produced a dinner that included the traditional foods I had eaten in my childhood, but tripled in quantity. It was a wonderful, daunting experience which began with *boreks*,

(cheese-, spinach-, or meat-filled pastries), eggplant soufflé, and cold poached fish, after which the meal began in earnest: meat, vegetables, rice, and on and on.

Hours later we sat stupefied, like felled oxen, around her table laden with countless cups of Turkish coffee, honey cake, candied fruit, baklava, and cordials.

"Tell me, do you want anything else?" crooned Dolly, who had promised a "simple family meal."

Her dinner reminded me of the groaning boards prepared by my Aunt Fortunée, famous in the Los Angeles Sephardic community both for their quality and quantity. If you were lucky enough to be invited to one of Aunt Fortunée's legendary feasts (even if you had taken the precaution of fasting on the previous two days), you sat down at her Rabelasian table with a sense of inevitable doom, although it was clearly self-imposed. It was *impossible* not to eat. The food was so delicious and so varied that my aunt's incantatory *"Manga! Manga!"* (Eat! Eat!) was equivalent to the hand that forces the food caressingly down the neck of a Strasbourg goose fated to become *cou farci* (neck stuffed with goose liver). Her guests protested loudly, but happily obeyed. Bloated, I sat at Dolly's table and wondered if the variety of food reflected Sephardic or Turkish habits, or both, and if the quantity was in our honor.

Finally I roused myself from a gluttonous daze and began to ask details about my father. What did they know or remember about him? The first surprise came from Berto. "He was born in Izmir." I had always assumed it was Constantinople.

Izmir had been known then as "beautiful Smyrna," the most important port on the Aegean and, according to legend, Homer's birthplace. This city of natural geographical charm, the home of a large Jewish community, was colonized by Aeolians in the tenth century B.C., then simply appropriated by the Ionians. Smyrna

was a flourishing place in the late 1800s. Her streets were broad and palm-lined, her port packed with merchant ships.

"Your father was the first-born son, always a position of honor in the East."

Evidently his sunny, gentle nature had endeared him to everyone. Then why had he left Turkey at seventeen? Because, Berto recalled, our Grandfather Moise had ordained he should go to America, "to the land where anything was possible," which at that time was indeed a place of unlimited opportunities.

I have a large framed photograph of this Grandfather Moise on the wall of my library; it shows an imposing, no-nonsense, yet kindly-looking man with steel-rimmed glasses, a large walrus mustache (did *all* Turks adorn themselves with mustaches? Certainly all my paternal uncles sported them, though of varying dimensions), a strong chin, and a broad forehead, which he had passed on to his first-born son. Next to the photograph hangs a medal given him for services to the sultanate—a marquisette and enamel dazzler hanging from a red star and crescent. Berto told me he taught religion and languages.

One of the stories that surfaced about my grandfather claimed he had represented the Sephardic community at the sultanic court and had taught languages to the young sultan. He was "an intellectual," "an *efendi*" (an honorary title of great distinction), according to his descendants.

At my grandfather's behest, my father had gone to New York. After his graduation from Erasmus Hall High School, his father's connections with the sultanic court had made it possible for him to study mechanical engineering in Palestine, at that time part of the vast Ottoman Empire. And then? I pressed on.

Berto's memory was vague. He thought he recalled being told that my father had helped engineer a railway for the purpose of transporting fertilizer from the inlands of Chile and Peru to the

coast. Had he really? I could barely fathom such a portrayal of my father in this role. Who else might possibly validate this outlandish image?

The father I remembered had been forced by the Depression to abandon his career as an engineer. He became an insurance salesman—at a time when the average man had difficulty paying his mortgage, let alone his insurance—a profession by which he uncomplainingly eked out a meager living, despite occasionally paying the premiums for his customers, all of whom became friends.

My mother's view of his generosity was less sanguine. Father frequently neglected to pay his own utility bills, without informing his wife. Despite so many years in America, he remained a staunch Turkish male concerning money. No need for the wife to know. Well, she found out when she received a notice that the gas would be shut off because he had neglected to send payment. His attitude was a punishing source of arguments that were never resolved and that haunted me for many years—the low moan of my mother's voice, the progressively louder sighs of my father, and finally his harsh "Let me have some peace!"

To me my father was unfailingly loving, humorous, and playful, and he willingly indulged my few requests. At one time I must have heard a phrase which made me ask, with a six-year-old's innocence, "Daddy, does money grow on trees?"

"Absolutely!" He took me into the garden, gave me a penny and told me to plant it in the ground.

"Now, tomorrow morning when you get up, look out your window."

When I did, I saw a miniature wire tree hung with shining copper pennies growing out of the ground! I have no doubt that my misguided belief that money *does* grow on trees, despite countless experiences to the contrary, is a direct result of that indulgent gesture.

But my cousin Robert remembered my father as somber: Perhaps Robert's unprejudiced view more accurately reflected the man's true state of mind. He could not have been fulfilled in his work. He returned to engineering only at the advent of World War II, and for two years before he died he shed the carapace of the tired insurance salesman, and another man emerged.

Father blossomed. World War II gave him the opportunity to use his technical gifts again. On Sundays during those years he often drove my mother and me to the small aircraft plant where he worked, to show us with great pride some new tool he had designed and made. For the first time in my memory, money became plentiful. He bought *two* new suits to take the place of the shiny black serge one I had assumed he had been born in.

And then, one day, his colleagues at the plant brought him home, saying he had become ill at work. His face was pasty white and he was barely able to walk. They helped my mother undress him and put him to bed. The family doctor was called. Two hours later my father was dead of a massive heart attack at the age of fifty-six.

When my mother took me into the bedroom to see him, I couldn't touch him. This inert body wasn't my beloved father. I felt absolutely unable to express my terrible sense of loss and abandonment. I pushed my grief far, far down somewhere. But many years later, when my husband's father, whom I dearly loved, died in much the same way, my mother-in-law took me into the bedroom to see him. "Feel his hand—it's still warm!" she cried. And when I did, I wept for my father as well.

While their information about my father was scant, Berto and Dolly told me much about his mother, my Grandmother Mercada. Far from beautiful—plain, in fact—she was nevertheless feisty and independent, and was loved uncritically by her husband and children. I learned that after my father died, his dutiful brothers

wrote letters to her over his signature for fifteen years until the ninety-four-year-old matriarch died, still believing her beloved son in America was alive and well.

That was in character with the paternal side of my family: no drama, no self-aggrandizement. My Uncle Norman was imbued with that same sense of duty and modesty. After my father died, he simply put a certain amount of unasked-for money into my mother's bank account each month, mute as the grave. I learned of it only years later. Mother never mentioned it, although she certainly must have been aware. After all, where else would that money have come from, so far beyond her meager earnings? No one spoke of it. But there was a quiet affection and understanding between those two that had nothing to do with the turbulent relationship she had with her sister Fortunée, Norman's wife.

When my Uncle Norman died, my aunt came across thirty years' worth of cancelled checks and found that he had also been sending money monthly to his younger sister Kamer in Paris, whose financial situation was tenuous.

And, finally, we talked about the house on Büyükada. They had all spent extended periods there—weekends, summers. Yes, I knew about it, I told them, and I was eager to see it. Berto told me that Aunt Nouriye was still living there, and that only she had a key, but at present she was visiting her daughter Lisette in Ankara, so we couldn't get in. I would have to wait. Nevzat said he promised to call as soon as she returned.

The house, though still unseen, now seemed a closer reality. It sat there on the island of Büyükada in the back of my mind, like some tantalizing present as yet unwrapped, containing—what? I didn't know.

Menace on the Bosphorus

MY HUSBAND, now a psychologist and professor (the young composer I married eventually came to the reluctant conclusion that no one would buy his sonatas), had been invited to give a lecture at Boğaziçi University, the result of an earlier series of serendipitous events. He met someone who knew the rector of the university, who, his acquaintance assured him, welcomed foreign lecturers. Courteous letters traveled back and forth. Arrangements of time and place were made.

The rector was one Aptullah Kuran, an internationally acclaimed expert on the architecture of mosques who, at that time, was the head administrator of Boğasiçi, formerly known as Robert College, the first American college abroad with classes taught in English.

Since 1860 Robert College had been where the children of educated Turks, as well as as the children of Europeans living in Turkey, were sent for higher education. It was in this high, forested, idyllic setting overlooking its namesake, the Bosphorus, that I caught my first glimpse of the schism that was forming just below the country's religious crust.

On the campus I noticed some few women students in long black dresses, their heads covered with white kerchiefs: fundamentalist Muslims. They huddled closely together at the periph-

ery of a swarm of students in western dress. Then-President Kemal Atatürk's rigid insistence on the westernization of Turkey had forced religious orthodoxy underground—Atatürk would have preferred to put an end to it entirely—but obviously hadn't erased it. Was it resurfacing?

During a lavish lunch following my husband's lecture, I asked our hostess an indelicate question.

"Do the fundamentalist students pose a problem? Do they interact with the others?"

Mrs. Kuran, an American who navigated Islamic waters with a combination of cosmopolitan grace and American know-how, answered with an exquisite example of eastern opacity that told me nothing:

"We are in the East, after all."

Two days later we received a telephone call from her. Would we care to take a drive along the Bosphorus in the company of her Turkish friend? We accepted eagerly.

Mrs. Kuran and Mrs. Bezir, a plump partridge with merry cinnamon-colored eyes who spoke no English, picked us up at the Pera Palas and we began a drive that paralleled the length of the Bosphorus with Asia (Anadolu) on one side and Europe (Rumeli) on the other. The drama of this strait was immediately apparent.

The most important fact about the Bosphorus is this: it splits Turkey in two. Turkey reflects that bisection historically, geographically, and deep within its psyche. Behind the sleepy little towns framed by wooded hills that lined the Asian side was the beginning of Anatolia, with its way of life unchanged for centuries. But Anatolia had begun to resemble a glacier responding to irresistable forces: This vast tableland was just now starting to rumble and stir, politically and economically.

In contrast was the European side. Restaurants, both simple

and elaborate, ugly concrete buildings topped with garish neon
signs, competed with luxurious villas and *yalis*—the formerly ele-
gant fretted wooden summer homes of ambassadors and consuls,
which were now abandoned and tumbling into the Bosphorus. It
was a would-be western culture stubbornly proclaiming its signifi-
cance in a sliver of history-laden land.

We ate at one of the seafood restaurants that lined the strait. A
wooden deck sloped seamlessly into the water, making a passage-
way to gently rocking boats filled with a small ocean of turbot and
red mullet (*barbunya*). Fishermen slithered their catch into a
large, concrete tank for our inspection and choice.

We sat outside at a wooden table and enjoyed a leisurely meal
of grilled fish, salad, and sweet fresh bread, washed down with a
delicate white wine, and topped off with the dense syrupy coffee,
and fell into a *keyif*, the Arabic word for the kind of idly dreaming
relaxation which the Turks have elevated to an art.

I recalled my father's Sunday afternoons on the couch. He
wasn't like my American friends' fathers, beached whales all, who
sprawled on their sofas, faces covered with the sports pages of the
newspaper, asleep and snoring. Instead, my father lay like a sun-
drugged bee, one finger on the page of an open book, neither
asleep nor fully awake, but sunk into a sort of seductive reverie. At
such times, my mother would gaze at him affectionately and call
him "Pasha," an honorific title traditionally bestowed on oldest
sons or ancient retainers.

After lunch we continued along the shore of the Bosphorus.
The plump, white ferry boats zigzagging placidly from the Asian
to the European side created a scene so benign, one could almost
forget the critical fact that this short strait—a mere eighteen
miles—was the key to Turkey's dominion of Asia Minor. Only
through the Bosphorus did the Soviet Union, Bulgaria, and Ro-
mania (the last two landlocked on the Black Sea) have access to

the Mediterranean from the Sea of Marmara, past the Dardanelles, on to the Aegean, and into the Mediterranean, the "Roman Bathtub," that body of water that is the hub of European and Near Eastern maritime commerce.

Where the strait began to narrow, Mrs. Kuran suddenly stopped the car and turned to me, smiling. "You must make an offering to Tellibaba." I stared at her, uncomprehending. She explained, "He was an old man who had a fondness for brides, and brides traditionally made a pilgrimage here before their weddings to receive his blessing. Even though he is gone, you can lay *geliteli* on the figure of Tellibaba for good luck. You needn't be a bride; the luck applies to all visitors. Come along and make a wish."

I turned to my husband, who remained baked in his seat. He smiled wanly and nodded me on. He was clearly not going to accompany us. Mrs. Kuran walked me down a grassy knoll to a small building with a narrow entrance like that of a cave, where she purchased a strand of silver paper icicles, similar to those hung on Christmas trees—*geliteli*. Then she turned and walked back to her car, leaving me alone.

I went in, feeling foolish and more than a little apprehensive. A primeval, occult aura seemed to float about in that tiny crypt-like chamber. I was surprised to feel a little shiver of fear—simply an example of primitive belief, that's all, I muttered to myself. In the semi-darkness I perceived a life-sized figure of a recumbent man who lay buried under a huge silver blanket—*geliteli*, yards and yards of it.

My first instinct was to turn and run, but I was restrained by embarrassment. After all, went the silent conversation with my secular self, the only power this cave possessed was that which I was willing to grant it, wasn't that so? And to prove that this icon held no terror, I went up to Tellibaba, lay the strands of icicles

across the area of his heart, made my wish, and scrambled up the incline to the car like one pursued by demons.

We drove on, and soon after, two lighthouses, one in Rumeli, one in Anadolu, proclaimed the end of the Bosphorus and the beginning of the Black Sea. We veered west. Imperceptibly, the landscape changed. The Balkans were now at our back. Gone were the concrete buildings and the little seafood restaurants. In their place was a backdrop of mountains, their rigidity camouflaged by pines. The air became cooler, clearer.

Shortly, Mrs. Kuran stopped the car and led us through a pine forest, down a steep weedy path and onto sand and an expanse of calm blue water. We were on the Black Sea. Behind us was a rambling hotel, unoccupied now in the autumn, its windows like so many sightless eyes. On the veranda a long row of empty wooden chairs faced the sea—the universal melancholy sight of a holiday resort off-season.

"Do you know why it is called Kara Deniz, the Black Sea?" asked Mrs. Kuran. We shook our heads.

"Because this is where people empty the grounds of all the Turkish coffee cups!"

Delighted with her joke, she translated it for her friend, and those two sophisticated ladies dissolved in giggles like teenagers. We watched as Mrs. Bezir motioned to us and said something in Turkish to Mrs. Kuran.

"Mrs. Bezir would like to invite you to her home for tea. She thinks you might enjoy seeing a typical Turkish home, and she would like you to meet her daughter, who is an artist. Would that please you?"

Of course. So we doubled back along the Bosphorus to Mrs. Bezir's apartment. A long living room was furnished with low copper tables, several sofas covered with kilims, and pillows strewn all about. A veritable shop of Turkish rugs lay on the floor. A shaft of

golden afternoon sunlight came through the paned windows. I felt as though I'd been gently dropped into a pot of honey.

Mrs. Bezir's daughter entered the room. She was in her early twenties, with an abundance of chestnut hair, enormous almond eyes, and a mouth like a ripe fruit. Despite the fact that she was dressed demurely in a simple skirt and blouse, she could have stepped out of an ancient painting of a harem beauty. I could easily imagine some elaborately ornamented sultan, with his assumption of absolute power, claiming imperial entitlement to an immoderate collection of women looking exactly like her.

The harem, unquestioned for some four hundred years, inspired many besotted romantic descriptions by western writers and painters, who immortalized these women on paper and canvas. But the harem was also a degrading, repressive system of slavery. It circumscribed the lives of countless girls smuggled out of Anatolia, Africa, and Asia for sultanic indulgence. Those women became old, and spent the rest of their existences in impenetrable isolation from the world outside the harem.

This modern Turkish girl, several generations removed from her harem sisters, brought in small glasses of sweet tea on a brass tray and took over the job of translation from Mrs. Kuran.

"Would you like to see my paintings?" she asked in a low, mellifluous voice.

I looked around. A number of traditional, well-executed but static paintings of chrysanthemums and roses were hung on the walls. Hers, I assumed. I began to formulate in my mind some meaningless but courteous neutral phrases: "An interesting composition. Your color sense." But she went into a room off the salon, then reappeared bearing a huge canvas, which she leaned up against the wall.

Angular figures clutching machine guns and bayonets, their

faces soaked in blood and twisted by rage and anguish, marched across a backdrop slashed with black paint. Behind them, young people with raised fists held placards aloft. Bullets rained down from a darkly menacing sky. The whole astounding scene was one ferocious howl of fury, indebted consciously or unconsciously to Goya's *The Disasters of War*. The girl went back into the other room and brought out another canvas, a sister to the first.

"Do you like them?" She might have been asking if we liked the tea cakes.

We were stunned! We had been prepared for chrysanthemums, and were rendered mute before such unrelenting violence. Finally, all pretty phrases forgotten, I blurted out in complete honesty, "They're extraordinary!"

I was so galvanized by the immediacy of the message that I asked about the political situation from which it sprang.

"Things are very bad," the daughter volunteered, eager to go on. "The politics—"

But Mrs. Bezir shook her head in distress, obviously uncomfortable with the subject. Her daughter bowed her head in obedient silence. I wondered how the girl was able to compartmentalize her life between the reality of the streets and her mother's deliberate blindness.

But in deference to our hostess and Mrs. Kuran, I asked no more questions about what was becoming increasingly evident: A sinister battle rife with intimations of anarchy was rending this country in two, but I was ignorant of origins and issues. We parted in an atmosphere of the Emperor's New Clothes—polite negation in the face of obvious ferment.

"So far, none of our students at the Boğaziçi have been killed, *mashallah*," offered Mrs. Kuran as she drove us back to the hotel. Her comment was weighted with significance—a veil had been lifted for a moment. But only for a moment. The silence that

followed forbade further discussion. The subject was closed, not to be reopened.

When Mrs. Kuran dropped us back at the Pera Palas, my husband decided to take a short rest before going out for another memorable restaurant meal with Berto and Dolly. But I was still agitated from the afternoon's experience, and opted to walk around the neighborhood near our hotel, an area filled with used-book stores.

I stopped at one store that was piled high with books in English, French, German, Swedish, Italian, Arabic, Greek, Turkish, Persian…I lost track. Books lay pell-mell all over the floor and on rickety tables. They were crammed three deep onto sagging library shelves. A seedy-looking man sat reading, hunched over a desk entombed in papers. He had the doomed mien of an assistant professor who has long ago relinquished any hope of achieving tenure. He didn't look up when I entered.

I began to calm down in this familiar atmosphere. Serious bookstores throughout the world have the same dusty, cluttered look, and their frumpy booksellers are interchangeable. All of which I found comforting—until the harsh shriek of sirens shattered the peace. Two police cars whipped past the store.

Behind them, a phalanx of silent young men and women, dressed in Istanbul's ever-present black, pressed against a wooden coffin held aloft by eight men. They walked glued together, their faces like stones, leaving a wake of menace in their path. The bookseller looked up. He muttered something in Turkish to no one in particular. Again, my apprehension rose to the surface.

"What is happening?" I asked the man in English. He answered me in kind.

"Another student killed. One is killed every day. They've been polarized, these unfortunate children."

"Over what?"

"Over the government, the political situation—the rightists, the leftists—"

I interrupted. "Who are the leftists?"

He sized me up silently, for a moment. "The leftists are who-ever you want to believe they are, madam. Liberals, students, idealists, Communists, troublemakers. It depends on which news-paper you read. The situation has been getting worse since 1970. This country can no longer be governed. Something is going to happen soon, and the military will take over...."

"A military coup?" A gong set up alarming reverberations in my western mind.

"No, no. In Turkey, the military exists to protect from the out-side and from within. When it becomes impossible for the inter-nal situation to continue, the military steps in to bring order." He could sense my doubt. Like a pained tutor cursed with a dimwit-ted student, he was determined to educate me despite myself.

"The Army sees itself as the guardian of democracy. Do you understand that? It is our legacy from Atatürk. I will give you an example: The Army took over in 1960 when the government did not function..." and he launched into an encapsulated political history, which I thought at the time, though didn't say so, was a bi-ased one.

What he described as "peace-keeping" sounded like a coup to me. But he was absolutely right. Two years later, tanks rolled through Istanbul and Ankara; the dissolution of all political par-ties and organizations was ordered. Martial law was declared, and the military did indeed take over.

But while we were there, even though the military was very much in evidence and the aura was one of palpable violence, no actual takeover occurred. That night, over dinner with Berto and Dolly, we voiced our concerns and discussed the possibility of al-tering our original plans, which included driving down the

Aegean coast and into Anatolia. We would be wise to skip these two areas entirely, or spend less time in Istanbul, they warned us. I had traveled 7,000 miles to see this country, had just begun to dip into it, and now I felt pushed by circumstances completely out of my control. I was in a landscape without a map, without a guide, surrounded by that underlying sense of peril that had dogged me from the beginning. Much of my father's early history was still veiled, and might remain so, but I wouldn't know until I'd explored it further.

And then there was the house on Büyükada. When would I be able to see it? Berto said that Aunt Nouriye was still in Ankara, so the house was inaccessible. But if she returned before we left, he or Nevzat would take us there.

On our fifth day, while exploring Taksim Square, in the European heart of Istanbul, we stopped in for a cup of coffee at the Inter-Continental Hotel. We left after one hour. The following day we learned on the radio that "terrorists," whether from the right or left we never discovered, had positioned themselves on the roof of a building opposite the hotel on the previous afternoon, and machine-gunned whoever emerged. Nine people had been killed.

We cut our Turkish visit in half.

The Sacred

OUR RELUCTANT DECISION to truncate our planned twenty-one days in Turkey into a mere week introduced another factor—urgency. Two of the celebrated mosques in old Stamboul, the Suleymanie and Aya Sofia, would have to share a morning, and the archaeological museum and the Topkapi Saray would be crowded into one afternoon.

We began with the sacred. Five times a day the faithful are called to prayer by a muezzin:

God is most great! God is most great! I testify that there is no God but Allah. I testify that Muhammad is the prophet of Allah. Arise and pray; arise and pray. God is great; there is no God but Allah!

In small towns and in the countryside, it is the muezzin himself who stands on the balcony of the minaret and chants his call to worship. But in Istanbul, the supplications are recorded and sent out over loudspeakers mounted on minarets throughout the city. I was never able to find out if individual muezzins in Istanbul made their own recordings, or if some religious entrepreneur produced one record for mass distribution.

Whichever it was, the calls seemed just slightly out of tune and off time. I could hear their ululating echoes throughout Istanbul—on top of each other, beside each other, a millisecond,

afterward like a hiccuping fugue—all floating in the gauzy air, insistent, hypnotic, in whining competition with the blasts of cacophonic automotive horns.

At the muezzins' calls, gulls who had taken up residence on the narrow balconies of the minarets wheeled about, then circled back to their perches in a single unbroken loop. Believers, in obedience to Koranic law, faced Mecca and knelt in prayer.

Once again we crossed the Galata Bridge to Stamboul and headed for the mother of them all, the Aya Sofia, or Church of the Divine Wisdom. As everywhere else in Turkey, commerce persists regardless of venue, be it in a bazaar or at a house of worship. So it was not surprising to see vendors of guidebooks, postcards, and rugs—always rugs—surrounding Aya Sofia on all sides.

At the entrance to Aya Sofia, a growing platoon of tour buses—Eurotours, Turkoreisen, Pashatours—spewed out gazers and pilgrims from across the globe. It was still early morning, so the deadly pallor and glazed eyes of the stunned tourists were not in evidence. For the moment they descended the buses briskly, clutching their guidebooks, eager to be informed, ready to be amazed.

We followed them into the church, built in 330 A.D. by Emperor Constantine, who had perceived his power as absolute, his divine right as representative of God on earth.

Constantine's church, destroyed during the Nike Revolt and rebuilt by the eastern Roman Emperor Justinian 223 years later, while certainly conceived by the ruler as a gift to medieval Christianity, was yet another act of hubris. What resulted was this greatest of Byzantine churches. Upon completion of Aya Sofia, Justinian was alleged to have cried, "Solomon, I have surpassed thee!"

In Aya Sofia's third metamorphosis, the Ottoman conqueror Sultan Mehmet II wrenched it from Byzantium, declared it a mosque and following the strict dictates of Islam, which forbids

depiction of the human face, plastered over most of the glorious mosaics and frescos of its former incarnations.

Finally, in the time of Atatürk, the plaster was removed and the mosaics and frescos re-emerged, as though woken from a long slumber. This was the happy fate of a tender tenth-century Virgin in the apse, along with blue-winged seraphim below the arches that held up the dome.

After Aya Sofia had seen nine centuries as a church and five as a mosque, Atatürk changed the customs and institutions of his country irrevocably, and Aya Sofia became secularized. Justinian's church became a museum.

Despite Aya Sofia's history, somehow none of those imperial seizures appeared to have touched the essential spirituality of that church/mosque/museum. It rendered me mute.

I tried to separate the particulars that added up to this sense of spirituality. Was it the cumulative effect of the lambent light that flooded through a corona of forty arched windows? Was it the enormous dome, high as a fifteen-story building, which seemed to float weightlessly in a breathtaking victory over gravity?

Standing in the midst of this inspired piece of architecture intended to stimulate religious inspiration, I was fascinated by the paradox that intimacy existed in such a vast space. Thousands of people visited it daily. But despite their rustling footsteps across the mosaic floors, almost more felt than heard, there existed within those four acres a silence that was reverential. And I, a nonpracticing Sephardic Jew turned western agnostic, found it perfectly natural to believe that contained within Aya Sofia was the ancient soul of Byzantium.

A mosque of an entirely different persuasion was the Suleymaniye Camii, crowning the third of Istanbul's seven hills and designed by Turkey's greatest architect, Mimar Sinan.

The particularity of this mosque was expressed in devotion to

prayer and the practical representation of the tenets of Islam. It was first, of course, an unobstructed prayer hall. The massive central dome—175 feet high—suspended from four solid square piers at the four corner, was a testimonial to those Byzantine and Ottoman secular designers who were masters at creating the illusion of weightlessness.

We walked around carefully, skirting the believers who knelt on the floor in prayer, while ignoring the quiet but constantly milling tourists. The vast room reverberated with a sort of low hum. The smell of old socks and pomade, mingled with that of candle wax, was strangely familiar and not altogether unpleasant.

Four hundred small domes burbled above the adjacent complex—eight connected buildings that translated into action Islam's imperatives, among them the duty to care for the sick and the poor. One could view these buildings as practical articulations of good deeds—a hospital, a school of medicine, a soup kitchen, a hospice for the poor, a Turkish bath and several *medreseler* (Islamic schools of law and religion). Belief, buttressed by practice, which solidified belief—a holy circle.

I thought about how this compared with my own sense of religion as an ambiguous business made untidy by several conflicting messages. There were oft-quoted beliefs of my Grandfather David, who, when other religions were brought up, always replied that it didn't matter which religion one followed, as long as the source was pure. Then there was my mother's idealized sympathy for Catholicism. It brought her troubles, in later years, when she fruitlessly tried to convert her unbelieving sister Fortunée (and anybody else in the family who would listen) to the belief that Jesus was indeed the only true Son of God. This came to be known as *l'etrange croyance de la pauvre Judith* (poor Judith's strange belief).

But there was also the closely knit Sephardic community, centered around southwestern Los Angeles, to which my parents belonged for reasons, I believe, probably more communal than canonical. It took this economically middle-class community a long time to build its house of worship, which was called El Kal from the Hebrew word for synagogue, *kahal*. I recall the groundbreaking ceremony on the corner lot that was to house the temple. The honor fell to the second wife of a respected patriarch of a large family to plunge a spade into the hard earth. Ah...*bueno*, Rebecca! Applause, prayers, and, later, inevitably, food. Witnessing this gesture, spade to earth, performed by a woman with dancing brown eyes, corseted in purple lace, I felt a sense of import.

In time, helped along financially by several families of means, the Temple Tiferith Israel was built. It was a two-story affair, designed strictly according to Sephardic stricture: women upstairs, men downstairs, in pews on either side of the room, in the middle of which stood the *bima* (pulpit). The ark, holding the Torah, was in the front. Across from the sanctuary was the Social Hall and its annex, the kitchen—the heart, for me, of my Jewish identity. Ritual prayer and solemn religiosity may have reigned in the sanctuary, but it was in the Social Hall, among bustling mothers, that children, myself included, darted in and out of the kitchen like magpies, plucking at food, tripping each other, and being shooed away like pesky flies by the orchestrating matrons.

I wonder, sometimes, what happened to that band of gamins informed by such a moderate god of mischief. Did they become homemakers like their mothers, or accountants and salesmen like their father? Did their sense of religion eventually lead them out of the kitchen and into the sanctuary...and why did it not for me?

As predictable as sunrise was the presence of a pretty, plump woman with marcelled hair, the eyes of a doe, and the serene smile of one who has never known anything but adoration. After

the inevitable feast, she was heaved up onto a table and implored to "Sing, Norma, sing!" The ritual never varied. She blushed, looked down, and said "No, no." The pleas increased. "Sing, Norma!" And after several more entreaties, each more fervid, she opened up her rosebud mouth and plunged into "Alla en el Rancho Grande," or "La Paloma," a full-throated thrush above a sea of upturned faces—our very own Lily Pons.

Since the modest community could not afford a fully-ordained rabbi, a *haham* (wise man, in Hebrew) was engaged, one Mr. V., a sweet, unassuming man who officiated at bar mitzvahs, deaths, and during High Holidays—which were the only times my parents attended. Many years later, Mr. V. was replaced by a real rabbi and (here I am guessing) retired with a puny pension. My mother, loyal to the death, claimed he had been put out to pasture with insufficient honor for his years of devoted service, and continued to treat him with the respect due a religious leader of full authority.

The High Holidays—Yom Kippur (the Day of Atonement) and Passover—I associated with food, and with an expectation of chaos, which invariably heightened the occasion for my cousin Robert and me. We could always count on a crisis in the kitchen on Yom Kippur since the men always returned late from the synagogue, which guaranteed the burning of at least one dish, accompanied by Aunt Fortunée's vehement exhortations to God:

"*¡Ai Dio mio elevado santisimo, que me muera y escape!*" (Oh, my exalted sainted God, let me die and be done with it!)

That litany, sometimes shortened to "*¡Ai Dio mio!*" was uttered by my aunt whenever disaster struck, be it news of someone's death or the fact that the laundryman forgot to deliver the sheets.

Passover was always held at the home of the Levys, friends of my parents. The hour-and-something ceremony was conducted

by the kindly, rumpled Mr. Levy, who read in a halting Hebrew, laced with Ladino, in a voice of such mind-numbing monotony that the children at the table were driven beyond endurance. They would eventually slide under the table, one by one, to gaze up the plump stockinged legs of the seated women; then, soundly scolded, they would emerge to tip over glasses of water and wine.

It was a warm, amusing piece of theater, suffused with the comfort of dependability. The scenario would be ever thus. But it did not inform me one whit about the spiritual nature of my religion; I would not begin to explore it or discover the connection with the holy circle of the Suleymanyie for many years.

On the way to the Topkapi Saray we passed a man carrying *simits* on a long stick—large, round breads with holes in the middle, like enormous pretzels, studded with sesame seeds. It reminded us that we were hungry, so we bought two and bit into the still-warm yeasty dough that smelled of country ovens.

Still eating, we crossed the bustling Divan Yolu Boulevard, a macadamed road that had once trembled under the barbarous advance of the Janissaries (the corps of highly trained soldiers who eventually became the terror of the Ottomans) and the Crusaders. Today the Divan Yolu, denuded of its former consequence, divides the Byzantine and Ottoman world of old Stamboul with Istanbul's twentieth-century cluster of milk bars, restaurants, bakeries, shoe stores, and leather shops.

The air was pungent with cooking odors, and we followed them like Hansel and Gretel to the front window of one restaurant, where we could see directly into the kitchen. A man of bombastic agility vaulted from one tray of food to another, pointing to the generous arrays of rice, bulgar, spinach, and that epitome of Turkish cooking, eggplant (*patlican*.) He spooned and served and

refilled huge receptacles in a seamlessly nimble culinary dance. When he saw us staring, our noses pressed to the window like hungry orphans, he broke into a wide, gap-toothed smile and motioned us inside. He pointed to one of the trays and closed his eyes in ecstasy. We decided on this place for the drama, if not for the food. Both warranted his salesmanship. We devoured the *patlican* in its many incarnations—*patlican* with rice, *patlican* with pine nuts, with oregano—finished off with some sweets, drowned in honey and washed it all down with tea.

Sufficiently revived, we pushed on to the profane.

The Profane

IT WOULD HAVE BEEN SENSIBLE, given the stimuli of all we had seen that morning, to stop with the mosques; but we mushed on to the Topkapi Saray—the palace and treasury—whose name conjures up visions of fabulous riches.

I had traveled a third of the way around the globe, and wasn't going to leave without a glimpse into the old Ottoman world of my mother's youth, even though in her day it was in the process of dying. I had to see something of the sultanic world whose twilight she had witnessed. If the mosques personified the sacred, this palace of Oriental excesses represented the profane.

Omnipotence, crusades, and thirst for personal glory were the fuels behind the forces that had produced all these buildings. The mosques were not exempt, of course, but the Topkapi Saray was in a class by itself. Fatih Sultan Mehmet had chosen an indestructible location for his "Palace of the Cannon Gate." It is poised on the hill that forms the tip of the peninsula that was once the Acropolis of Byzantium. Here, the Golden Horn unites with the Bosphorus. The spectacular location wasn't lost on Suleyman the Magnificent. He moved in and began the tradition of royal residence that lasted for the next four centuries.

We entered the first courtyard, a large park, through a simple stone gate—the Bab-i-Humayan. It led through the Gate of the

Salutations into the second courtyard, and the official entrance to the Topkapi Saray where the pith of Ottoman power had once been concentrated.

The sultan's cabinet, the Court of the Divan, had been the political core of the palace and a labyrinth of intrigue. Attached to this courtyard was the cluster of apartments that had housed the eunuchs and the harem, over one sixth of the total area of the Saray. Six years previously, some hundred rooms of the harem had been opened to the public. Wouldn't my mother have been fascinated! Would they have corresponded to what she was told back then?

But on this day everything was "closed for repairs," according to a crudely handwritten sign. I was sorely disappointed. Alas, I would not have the opportunity to actually see what had existed only in my imagination: the claustrophobic life in the kitchens and baths and private rooms—some barely more than cells, I had read somewhere—the lifetime prison for that city of concubines and odalisques.

Nor were the cages (*kafes*) available for viewing, ghostly left-overs from a cruel, aberrant chapter in the history of those pilgrims of absolute power. One abomination merely substituted for another: Once strangling was abandoned as a form of control, the *kafes* were instituted. Suleyman II had spent years so imprisoned in one of them, as had Osman II.

But the famous treasury was open. It contained only a fraction of the richest hoard in the world—the rest was stored away in vaults and vast depositories—which was exhibited in the halls around the third courtyard. The treasury's walls were sheathed with glorious white, blue, and red Iznik tiles, decorated with tulips and carnations and sinuous vines that beckoned one into a floral paradise.

We entered a colossal repository of gold, jewels the size of

plovers' eggs, holy relics, extravagantly conceived jewelry boxes, opulent turban pins topped with great snowy feathers that must surely have belonged to birds of fantasy. What a trove for thieving magpies!

The sword of Osman was on display here, as well as gem-encrusted weapons whose consummate execution of design lulled one into ignoring the barbarity of their intent. There were elaborately decorated chairs of Oriental inclination, covered with velvet and tassels and gold braid, low enough to the ground to accommodate the cross-legged sultans, who had made sitting into an art.

Exquisite porcelain coffee sets reposed on ivory-inlaid tables; clocks that no longer kept time and a bonanza of mechanical contraptions sufficiently complex to rouse the most blasé of sultans were displayed on velvet. There were costumes from the wardrobes of baby sultans whose tiny shoulders were burdened with the weight of sultanic patrimony.

We saw portraits so minuscule that the artists must have executed them in certainty that their defiance of Mohammed's law against depicting the human face would be overlooked. We gaped at the eighty-six-carat Spoon Diamond, surrounded by its necklace of "lesser" diamonds, and the famed emerald dagger with its diamond-studded hilt curved like the tail of a scorpion—the coexistence of beauty and evil.

I was less shocked by the unbelievably vulgar size of some of these displays than by the seeming indifference to their upkeep. Many of the items were covered with a barely discernible vapor of dust, just enough to dull their brilliance.

The guards, far too few of them, slumped against the walls. They looked supremely disengaged, if not comatose. I wondered if this lack of care was a function of housekeeping insouciance or of impoverished governmental coffers.

The same question occurred to me when we entered the

damp Archaeological Museum, which shared a courtyard wall
with the Topkapi Saray. The answer came later from one of my
cousins, who verified my assumption that there was little govern-
ment money for museum upkeep. And then he pointed out some-
thing I hadn't considered: the concept of civic responsibility was
a recent one.

"Social custom, which influenced Turkish thought much
longer than western thought, mandated that all lands and all peo-
ple—*everything*, in fact—belonged to the sultan. The western
idea of 'common concern for the common good' simply didn't
exist. So it's not a high priority for the government."

I was struck by the chaotic spectacle in the first room of the
archaeological museum. It looked like the result of an earth-
quake. Not an unreasonable thought, after all, since Turkey is rid-
dled by faults and has been reshaped by violent convulsions. A
doomscape of broken columns, fallen capitals, and statuary lay
scattered on the floor as though tumbled there by recent tremors.

When we revisited the museum fourteen years later, the ad-
vent of tourist dollars had brought a change of attitude. None of
this chaos existed. Displays were gleaming, postcards were sold,
rooms were painted, guards were attentive. A proper museum or-
der and hush reigned.

But on this day in 1977 we walked gingerly around the mar-
ble debris to glass cases crammed with antique vases, ceramics,
and bronzes. In other rooms, enormous Greek and Roman heads
of sculpted marble were mounted on porphyry pedestals. They
looked at us through sightless eyes, and we gazed back, unsure
what wisdom they had to offer.

Then, in another room we stopped, riveted by the sight of an
immense, glowing white sarcophagus—the so-called Alexander
Sarcophagus. Uncovered in Sidon, in pristine condition, under
the guidance of one Hamdi Bey, whose knowledge of antiquities

earned him a position under Abdul Hamid, it was originally thought to be that of Alexander the Great, but its date belied that. Depending on which book one read, it belonged either to an admirer of the conqueror or to his father, Philip of Macedonia.

On all sides of this luminescent stone coffin were scenes exquisitely carved in bas relief and tinged with polychrome. It appeared to have been created yesterday, so white was it. I was seduced into following the frozen pageantry of a panther hunt and, on the pediment, a balletic battle between Greeks and Persians.

I thought of all those triumphal arches I'd seen, of all those Cesarean heads so supremely wrought that I ended up hypnotized by their aesthetic and forgot that at the base of their glorification lay, always, the reality and brutality of conquest.

As blunt a reminder of conquest as any other was the Hippodrome. The ancient stadium, a great sports arena at its apogee in the time of Justinian, had once been the resting ground of the beautiful bronze horses of Lysippus. During the Crusades, the Venetians, ever envious of Constantinople's glory, spirited them off to Venice. They were placed over the central doors of the Basilica of San Marco, where they reigned until the ultimate destroyer—twentieth-century pollution—caused them to be brought inside for safety.

I still remembered my awe at those horses' look of nobility and at the snorting immediacy of their stance. They were about to gallop off—off to their original home in Turkey, I liked to think—and the stone walls of the basilica seemed barely able to contain their energy.

But after the Hippodrome I was exhausted. I was overwrought by the abundant display of glorious objects in the service of power; I needed the comfort of family and simpler lore. So that evening we took a taxi to Emile's house.

The perceptive Jenny recognized my enervated state and brought out a tray with tea and a dish of little honey cakes, and we settled down in their comfortable home to continue looking through her albums of old family photographs.

There, in her collection, was a sepia portrait of my mother as a young girl, dressed for the Turkish bath! I had never seen it before. She took very little from her home when she went to America. So few were her mementos from Turkey that I remembered them all by virtue of their rarity.

Her wooden bath clogs were among those few mementos. Intricately inlaid with silver designs, they had hung for many years on her wall, and now they hung on mine—a relic of my mother's girlhood visits to the baths.

"Which baths? Are they still open?"

"It could only have been the Cağaloğlu Hamam," said Jennie, referring to the eighteenth-century Turkish bathhouse, "and yes, absolutely, it still exists today."

"But we're leaving tomorrow!" I wailed, frustrated beyond bearing that I couldn't continue following all these leads.

"Look, my dear girl," said Jenny. "You're trying too hard. As for 'understanding' your background, too many tribes, too many cultures made up this land over the ages. The beginnings of Turkey go back to Neanderthal times. After all, we are latecomers. Even so, we Sephardim have lived here for five hundred years and absorbed a great deal from the cultures that preceded us. We're a composite of East and West. There's no way to separate them. They act upon each other. Yes, you must definitely get to know this history. Travel along the Aegean coast, and by all means go to Anatolia. But not this year. It's too dangerous. It's not meant for you to be here."

In the middle of this highly intelligent westernized woman's cautionary speech, I caught the unmistakeable whiff of eastern fa-

talism—"It's not meant for you to be here"—and thought that five hundred years of living in this land and absorbing its culture could not be erased by a mere half-century of western pragmatism. Considering my parents' descent from that long history, their acceptance of *inshallah* now became more understandable to me.

I reluctantly recognized that this trip was unfinished business. There still existed lacunae in my father's early years. I still hadn't seen the house on Büyükada. When we left the next morning, I was haunted by Jenny's words and convinced that we would never return, and I said as much to my husband. "We *will* return; I promise," he countered, unburdened by doubt. And he was right. But it would be fourteen years before we set foot in Turkey again.

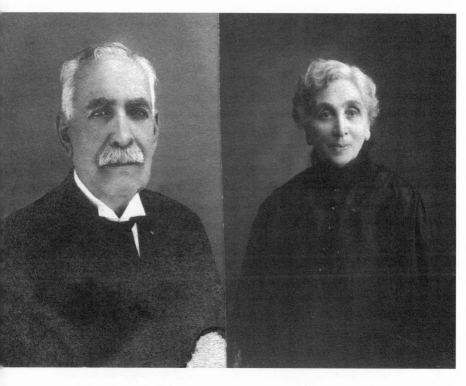

My maternal grandparents, David and Rebecca Fresco

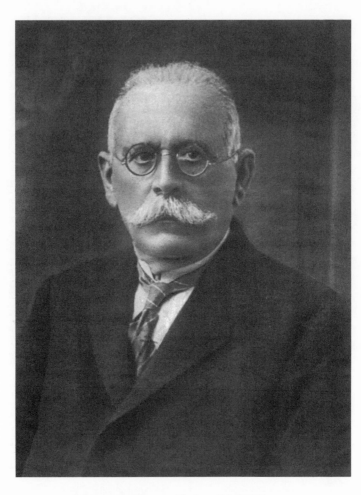

My paternal grandfather, Moise Fresco

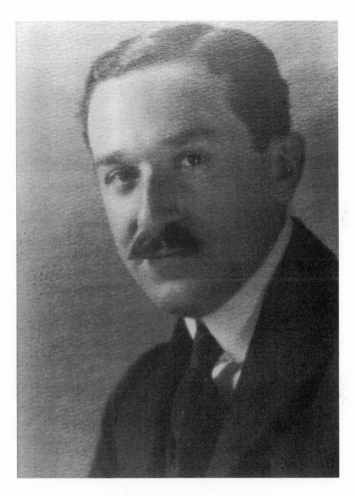

My father, Ralph R. Fresco

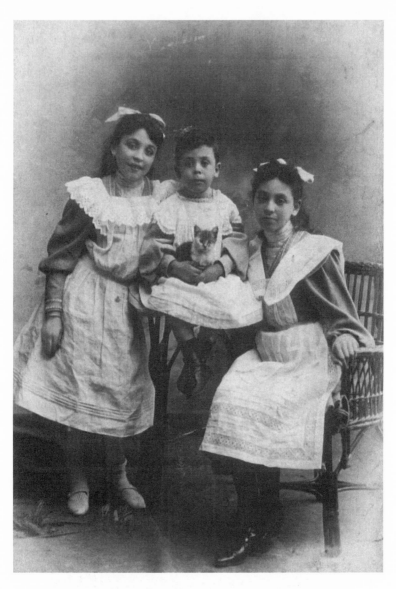

My maternal family, Fortuneé, Mauricio, and Judith

My mother dressed for the Turkish bath

My maternal uncles,
Isaac, Isaiah, Philon, Victor, Mauricio, and Leon

My mother and father on their honeymon
in Venice, Italy, 1920

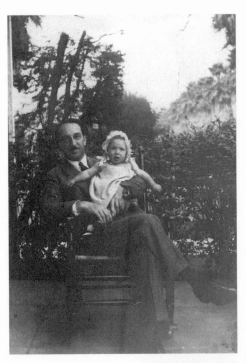

*Myself with my
father and mother*

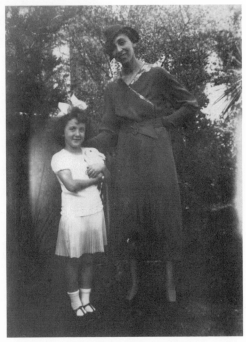

Eastern Standard Time

Istanbul, 1991. Fourteen years later.

From the airport we boarded a sleek, air-conditioned bus that sped past miles of gray rectangular apartment buildings—concrete eyesores—erected to house the multitudes that continued to stream in daily from Anatolia. They had been put up in such a hurry and so cheaply that almost overnight they had turned into tenements.

The only difference between this demoralizing landscape and those found girding the outskirts of all the great cities in Europe was the presence of mosques planted between the buildings, their minarets like imperative fingers announcing the presence of Allah.

When I heard the first hypnotic whine of the call to prayer, I felt an unexpected rush of joy. Scenes in my memory, like tableaux frozen in time, came tumbling out. A subliminal process of assimilation of my previous Turkish experiences had been going on during that fourteen-year interval, and now an emotional thaw picked up the sequence, ready to add to its store.

Of course! Perfectly *normal*, those imprecating muezzins, that nightmarish traffic. It was like finding a beloved book one had thought lost, and plunging into its pages again. By the time we reached the Yeşil Ev, our hotel in the Sultanhamet area of old

Stamboul, which I had chosen for its proximity to the heart of Byzantium, I couldn't wait to get on with it, wherever "it" led.

We found ourselves back in a city whose architectural glories had been cleaned up, but whose pollution had increased. The political climate, currently pacific and leaning west, was superimposed on an ancient Oriental pulse that beat undeterred.

The Yeşil Ev had been saved from certain disrepair by the head of the Turkish Touring and Automobile Association, who had lovingly restored this and several other nineteenth-century residences into comfortable small hotels that combined twentieth-century conveniences with the warmth and authenticity of typical Turkish wooden homes a hundred years ago.

Equidistant between the Blue Mosque and Aya Sofia, the Yeşil Ev sat on a little street shared with shops and restaurants. From our window, we could watch a rug dealer across this street daily drape his carpets over a giant easel he had placed against a rickety wooden wall. Crouched on his haunches all day and every day, he waited patiently for tourists to stop and buy.

"Pure vegetable dyes," he lied blandly when the wary questioned his sun-faded wares.

I called my family on the paternal side. Dolly and her daughter Terri had long since moved to London to join Moise, who had established permanent residence there. Many years later, while visiting Dolly in England, I asked her if she had found the transition from Istanbul to London difficult.

"Not at all," she told me with serene acceptance. "In Istanbul I took care of the house, I took care of Moise and the children, and I cooked. In London, I take care of the house, I take care of Moise, and I cook. There really is no difference."

Nevzat, now married to a young architect named Sabrina, had joined Berto in the family's electronics business. Over several *rakis* bolted down on the restaurant balcony of the Sheraton

Hotel—favored by Turkish businessmen—which overlooked the smoky maritime bustle on the Bosphorus, we were amused by the palpable teasing bond between uncle and nephew.

"He works too hard," said the younger. "From early in the morning until late at night."

"He always tells me what to do," said the older. It was obvious that concern and affection fueled their complaints.

And the house on Büyükada? It was empty now, and had been so for three years, since Aunt Nouriye moved to Israel to be with her daughter Lisette. She had given the key to Nevzat, who offered to take us there at our convenience. I stressed that this time I was not going to miss seeing it, not under *any* circumstances. I promised to call him as soon as we'd solidified our plans.

The maternal side—Emile and Jennie—remained. Jennie and I had corresponded rarely over the years, although each time I received a short note from her, that penetrating intelligence wrapped in an idiosyncratic worldview fairly leapt off the page. But now she was suffering from a debilitating illness. The golden hair was gray, the stride slowed. Still, her keen intellect and irreverent humor remained unscathed. We had returned, we told them, following Jennie's advice of fourteen years ago, determined to explore the Aegean shore and venture into Anatolia.

But first we took up where we'd left off in Stamboul. Near the Eminönü business section was Beyazit Square. It segued into a long, descending street jam-packed with the tumult of merchants bawling their wares, with scowling *hammallar* bent double beneath their leather humps, shouting as they advanced their fearsome burdens of furniture and wash basins and bicycles.

I was knocked sideways by one *hamal* carrying a mattress, only to be propped up by a tidal wave of people pushing their way through the human stream. We were swept along with them into the maw of the Kapali Çarşi, the famous Covered Bazaar.

Four thousand shops were clustered under a domed and vaulted ceiling—the largest bazaar in the world, according to the Turks. Hands reached out to grab us, demanding faces were thrust into ours; the peculiarly western assumption that everyone is entitled to personal space had absolutely no meaning here.

"*Jolie Madame! Gnädige Frau! Shalom, Shalom!* Hallo, lady! You buy rug?" If one address didn't work, another might. We reeled from the verbal, physical, and visual assault.

Within this free-market economy in its purest form, two facts of Turkish life were immediately apparent: The rug was the coin of the realm; and everyone was selling something. Even the legless man, his torso attached to a wheeled tray, had placed an old rusty scale in front of him and offered to read one's weight for a few lira.

The East hides nothing. The old, the bent, the maimed, are unapologetically on view and, in fact, *demand* your attention.

Radiating from the center of the bazaar out to the entrances were jewelry stores, one after the other, a stupefying dazzle of gold necklaces, watches, bracelets, and rings. As I headed toward them I barely escaped the supplications of a man who wheedled, "Why you don't buy rug?"

"I don't need a rug."

"Nobody *needs* rug. You *want* rug!" I laughed. He was right.

It brought up the memory of Uncle Norman, who regularly bought Oriental rugs, rolled them up, and stored them away in his garage, to my aunt's great chagrin. It made no sense at all, since he neither placed them in his already heavily carpeted house, nor made any effort to sell them. In fact, after he died, those piled-up carpets, like so many colored logs, were unrolled and found to be riddled with moth holes, rendering them useless for sale. I thought it strange at the time, because Norman was an astute businessman not given to profligacy.

But witnessing the activity there in the bazaar, I began to suspect that Uncle Norman's acquisitions sprang from some deep Oriental pocket in his psyche and were testimony to his belief that rugs represented a sort of pecuniary safety to him. Some people saved gold, "just in case." If you were Turkish, you bought rugs.

We wandered from store to store, stunned children surrounded by a pirate's glittering hoard of gold. And then we stopped. In the window of a corner shop, partially hidden beneath a cornucopia of elaborate jewelry, was a ring, simple and elegant.

A young man with moist chocolate eyes and a sultanic mustache beckoned us into the shop. We entered and he informed us, in impeccable English, that his name was Mustafa Akşam.

"Please sit down."

He motioned us onto small velvet-covered stools that lined the counter, then quickly clapped his hands.

A young boy sprang from behind a curtain, dashed out into the throng and three minutes later returned, delicately balancing a small copper tray suspended on three chains, containing two glasses of tea. I recalled V.M. Pritchett's apt description: "Two breeds in Turkey…those who carry and those who sit."

Mr. Akşam waved his manicured hand vaguely in the direction of the display window.

"You are interested in…?"

"There's a ring in the window," began my husband, stepping outside to point to it.

Mr. Akşam nodded. "Yes, yes. A very beautiful ring. An excellent choice. Would madame care to try it on?"

Madame would. Two small sapphires flanked a large ruby in the center of a simple flat gold band. I felt faint stirrings of desire. Did he have the same ring but with another stone in the middle?

"Of course, madame. I can make it up for you. It is not a problem."

"But we are going to leave Istanbul very shortly. It's not possible to return for a fitting."

"There is no need to return, madame. I will have it ready for you in thirty minutes. Simply tell me what stone you desire."

"Another sapphire, but darker?"

Again Mr. Akşam clapped his hands, then spoke in a low voice to the same young boy, who again bolted out of the shop.

"I will show you *many* sapphires. You can choose which one you like, and I will have the ring made up for you. Only thirty minutes. Perhaps you wish to explore the bazaar in the meantime?" Agreed. I left my husband talking to him and sipping tea.

Initially, the bazaar seemed an incomprehensible maze of alleys vanishing into dim passages and cul-de-sacs. Tiny shops were crammed with jumbles of new and old hammered copper pots and urns and hubble-bubble pipes of every style, from the strictly utilitarian to the severely overwrought, and trays with tulip motifs beaten into them.

There were shops that displayed only old silver, including pearl-handled fruit knives, their serrated blades worn smooth, tarnished dinner bells for summoning servants, and engraved coffee spoons long orphaned from their sets. There were shops that displayed jeans and cheap imitations of sultanic slippers pasted with fake rubies, the toes upturned, the soles plastic. Vintage radios blared out static rock; inferior leather goods dyed garish colors vied for sale. The odor of tobacco that permeated the area mingled with the scene of Limon, Turkey's ubiquitous cologne.

It seemed to me that every second shop displayed carpets. In their gloomy depths I could make out the shadowy figures of several men sitting, smoking, and drinking tea in silence. If, by chance, one happened to spot me peering through the window,

he would invariably rise, hurry toward me, and urge me to "Come sit, lady. Have tea. I show you beautiful rugs. What size rug you want?"

And then I discovered that the alleys and streets had names— Keseciler, Sahaflar, Yağlikcilar—that an actual order existed in the apparent chaos, and that the tea-boys who crisscrossed the alleys like darting fruit flies, delicately balancing trays of glasses without breaking their gazellic run, had rigidly prescribed routes. They knew exactly where they were going. The antique area was separate from the silver area, which was separate from the jewelry, and so on. I lost my way, then rediscovered it, and still managed to return to the jewelry shop in forty minutes.

"The boy is not back yet…just another ten minutes," said Mr. Akşam. "Please have some tea, madame."

I had some tea, this time on one of the overstuffed lavender velvet chairs against the wall next to two women. Both had several chins and faces like fruit about to turn. Western style dictated their high heels and expensive patterned silk dresses. But the East had the final say, with the white gauze scarves bordered in beads with which they covered their heads. They nodded and smiled. I nodded and smiled back and looked over at my husband, seemingly glued to his stool by the counter, sipping tea. After twenty minutes, I looked questioningly at Mr. Akşam.

"The boy should be here any minute. It is very unusual. I will call, madame."

He turned his back to me and picked up the phone. I heard a muffled conversation, then he turned to me.

"Just another ten minutes, madame."

I sipped my tea. Twenty minutes later, the boy came running in with a tiny package wrapped in tissue.

With an operatic gesture, Mr. Akşam broadcast some fifteen sapphires across a black velvet cloth. He picked up each one

delicately with a pair of jeweler's forceps and held it up to the light. Some I discarded as too dark, others as too light. None was exactly right. I shook my head, apologetic but determined.

"I really want a color between this one and that one," I said, pointing to a stone at either end of the blue spectrum.

"Of course, madame. It is not a problem. I will get it for you. Just wait ten minutes and it will be here, I promise. Please, have some tea."

The boy was still absent at the end of ten minutes, and Mr. Akşam suggested I wander through the bazaar again and return in twenty minutes. His manner was solicitous; he seemed genuinely distressed by the delay. And now I really wanted the ring.

Once again I plunged into that clamor of noise and movement, recalling what I had learned fourteen years ago. If grabbed and coaxed, I was to smile and shake my head. If the person became too insistent, I was to stare fiercely at him and say loudly and firmly, "Yok!"

When I returned to the shop, I found that my husband had undergone a Turkish metamorphosis. Sipping tea and gazing into space with the grace of a pasha, his rhythm was now in synch with that of the East. He seemed perfectly satisfied to sit indefinitely in that state of suspended animation. He would have sat cross-legged, I thought, had the breadth of the stool allowed.

The new sapphire was waiting. It was perfect. I nodded approval and said to Mr. Akşam, "It will take ten minutes to put in, yes?"

He smiled. "Perhaps twenty is more prudent."

I was back again in the bazaar. The whole scene put me in mind of my Uncle Fred's (Feridun, in Turkish) store. He was one of my father's younger brothers who, in the early 1920s, had moved to Catalina, a small tourist island off the coast of Southern California, where he had opened up one, then two, then three

shops called Fresco's Souvenirs, each a miniature bazaar choked with tawdry merchandise, much smaller than this sprawling bazaar, but essentially the same.

The largest of Uncle Fred's stores was situated on the island's main street, directly opposite the passenger boat pier. Twice a day during the summer big white ships from the mainland crossed twenty-two sea miles to Catalina and disgorged passengers into the beckoning maw of "Fresco's Souvenirs"—a triumph of strategic placement. Among a few genuine turquoise bracelets, shells printed with "Souvenir of Catalina Island"competed with leather coin purses that eventually bled on one's fingers from inferior dyes, jackknives with sham mother-of-pearl handles, and brooches made of fake plastic coral. The front of the store was separated from the "office" by a cord over which Uncle Fred had hung several would-be Oriental carpets depicting plump, semi-nude *houris* reclining on harem pillows. Behind the carpets was his desk and a soiled two-burner stove on which Turkish coffee was always brewing.

Fred was a kindly man with a pencil mustache and a French accent that earned him an unquestioned reputation as the local "continental." He remained on Catalina Island until he died, quite content to be a big frog in a little pond. In retrospect I realized that he was a brother to the salesmen in the Covered Bazaar who rocked back and forth on the balls of their feet in front of some undecided customer, crooning, "Take your time…take your time."

I wandered this city-within-a-city, which was erected in 1460. Two strong houses built by Fatih Sultan Mehmet became the nucleus of the maze of shops that sprang up around them like wild mushrooms after rain. Life here moved to its own ancient rhythm, and never more obviously so than in a rug shop.

I stopped in front of one. Some change must have occurred

in me—or maybe it was the ghost of Uncle Norman—because I
didn't hesitate to enter and announce that I had no intention of
buying a rug, but merely wished to look.

"Lady, please come in. Sit down. We will look at rugs later.
Now we have tea."

I had a moment of panic about my bladder. Where among
these four thousand shops would I find a bathroom, and how did
one ask for it in Turkish? There *were* bathrooms, of course, as I lat-
er discovered. But my bladder clamped shut, my panic abated,
and once again I was in the midst of the immemorial scene. One
of those hundreds of small tea-boys who inhabit all places of com-
merce dashed out into the bazaar and returned bearing the inevi-
table tray of teacups.

Several other sitters—men, each with an obligatory mustache
who looked uncannily like the actor Akim Tamiroff—smiled,
cleared their throats with ungodly hawks, and moved over to
make room for me to sit down on a mound of pillows.

The play had begun. Once again I was a participant in a time-
honored ritual whose rules never seemed to vary. First the tea,
then the leisurely exchange of personal information, *then* the dis-
play of the carpets.

"Where you are from, lady?"

"California."

A quiet buzz went up. Everyone, it seemed, had a friend or
distant relative in California, if not in Fresno, then in San Diego.
We discussed California's virtues. How many children did I have?
When I enumerated them and listed their names, as well as those
of my grandchildren, they nodded approval, and a twenty-minute
conversation ensued about the blessings of family. May God pro-
tect you...*Mashallah*!

By now, several cups of tea later, thirty minutes had passed.
Almost imperceptibly, a young man wearing felt slippers silently

glided into the room and unfurled a carpet at my feet: The mercantile door was now open.

"A *Hereke*," murmured the owner, wrapping his tongue sinuously around the name.

I was aware that he had begun the tease with a silk rug of the very finest weave, of the most elaborate design—and of highest price—and that all the rugs to follow would seem impossibly coarse in comparison.

As one carpet was piled upon another, they became progressively smaller and less expensive. Wool replaced silk, but the border of the original *Hereke* remained seductively in view. Finally I rose from the pillows and thanked each of the men in turn for his generous interest. They all stood up, bowed and nodded, smiles affixed to their faces with varnish, and I returned to the shop of Mr. Akşam.

"I went into a rug shop," I told my husband, momentarily disturbing his Oriental calm. His eyebrows went up.

"But I didn't buy."

His eyebrows came down, and he resumed his monolithic stance. I sat down on the velvet stool. The women who had been there before had been replaced by another pair, interchangeable in appearance. They didn't speak to each other, but smiled warmly at everyone who entered the shop.

Who were they, these women? Aunts? Nieces? Women who simply needed a respite from the exhausting business of shopping for jewelry? Or had Mr. Akşam hired them as store "decor"?

"It will be just another ten minutes, madame."

This time it was true. Almost three hours after the promised thirty minutes, Mr. Akşam placed the ring on my finger with the solemnity of a marital rite.

When we left the bazaar, my husband suggested we go to a cafe for a cup of tea. Miraculously, my bladder had adjusted to

the demands made on it. The suggestion seemed perfectly reasonable to me. We found a café outside the bazaar and had yet another cup of tea.

I decided that now was the time to explore the eighteenth-century Cağaloğlu Hamam, where my mother had gone as a young girl.

Parental Legacy

THE PHOTOGRAPH OF my mother dressed for the turkish bath had remained braided in my mind for fourteen years. I checked at the Yeşil Ev and, yes, the Cağaloğlu Hamam was still in operation. On a damp, windy day, our third in the city, I decided to go there.

The light of Istanbul seemed impenetrable, as if blanketed upon the city by eons of history. Finally, as the sun set, it burned its way down through the layers of clouds burnishing all it touched—a Turner tinged with menace—and drowned.

I navigated my way through the narrow cobbled streets of old Stamboul, clotted with people bent on business and *hammallar* bearing their horrific burdens with their raspy shouts of *"Varda!"* (Out of the way!) a transposition from the Venetian gondolier's *"Garda!"* No one seemed to amble in this part of town.

Every half-block or so I stopped and plucked at the sleeve of some man or woman and pointed to the name of the bathhouse I had written on a piece of paper. A dozen pointing fingers finally brought me to a squalid gray building with a sign above: CAĞALOĞLU HAMAM.

I knocked on the door. When it opened I glimpsed men of various dimensions, some clad in large white towels, some not, emerge then disappear into large white billows of steam. A tiny bent man with a boiled face stepped out, quickly closed the door

behind him, and shook his head violently. I had inadvertently knocked on the door of the men's bathing section.

"*Hayir! Hayir!*"

He thrust a soiled piece of cardboard at me, a crudely-written bathing menu for the women's section, which declared in Turkish, French, German, and English:

No. 1: 12.50 Turkish Lira—Wash You

No. 2: 20.00 Turkish Lira—Attendant Wash You

No. 3: 30.00 Turkish Lira—Attendant Wash You. Massage You. Massage à la Turk.

Massage à la Turk? Irresistible! I pointed to number three. The old man took my hand in his moist one and led me around the corner down a narrow, dark alley to the side of the building. A gray cat shot past us.

What was I doing here, propelled forward by a bleak wind and the unintelligible mutterings of a little man wrapped in a towel? I knew perfectly well that I had fallen prey to cinematic propaganda by countless Warner Brothers spy movies of the 1940s, and by all those Oppenheimer mysteries I'd devoured when very young. The action was invariably set in Sofia or Constantinople or in some fictional country with a name ending in "-ania." Dated theatricality, all of it. But my irrational feelings remained: People *had* been known to disappear in just such narrow, dark alleys.

The man knocked on an unmarked door. It was opened cautiously by a handsome gray-haired woman of sixty—not Turkish—who addressed me in English.

"Yes, madame?"

"I would like number three, please."

"Understand—you will be bathed by an attendant and then massaged. Agreed? Good."

She led me into a circular room surrounded by a series of private cubicles, each furnished with a wooden cot, a large towel draped over a hook, and a pair of clogs on the slatted wooden floor. She told me to undress and wrap the towel around myself. As I closed the door to follow her, she turned a heavy key in the lock, removed it, handle and all, and handed it to me.

We entered an anteroom with many white-tiled stalls. She waited while I showered, then pulled open a massive door. I was in the sanctum, transported back two centuries into an enormous mosque-like room fashioned entirely of gray marble. One continuous bench belted the circular walls, with intricately-carved fonts of warm water.

I looked across the vast space. Three naked women sat motionless in various positions, chimerical figures on an ancient frieze. My hostess clapped her hands and called out.

"Nayile!"

A Rubenesque young woman with snapping black eyes appeared out of the suspended mist, naked except for tiny bikini pants, her flesh steamed pink, her enormous breasts hanging lazy below her belly.

"Hallolady."

She led me to the bench with the firm hand of a kindergarten teacher introducing a new child to the classroom. Removing my towel, she dipped a brass pan into the water from the font, poured it over me and motioned for me to imitate her.

When I was thoroughly drenched, she led me to the center of the room to the *göbek taşi* (belly stone), a massive circular platform of marble elevated a foot off the floor, indicated I should lie down, and placed a little rubber pillow beneath my head.

Then, armed with a course, black mitten, she began to scrub me all over with the intense concentration of a cat cleaning itself,

alternating the mitten with swishes of a horsetail doused in a bucket of suds.

Until now I had been intensely alert to every detail. Originally apprehensive, I became curious, then an avid observer—and finally a willing participant. The witchery of warmth and steam and parental legacy prevailed. I yielded to the East. Sprawled under the woman's scrubbings, I gazed up at the domed ceiling. A late-afternoon sun shone through its oculus of blue and purple glass, plunging Rosicrucian rays down through the steam, painting cobalt and amethyst tattoos on the bodies of the bathers. The sound of splashing water...the rest, silence.

She dashed a bucket of water over me, rinsing away the soap, then began to knead my body, her great breasts swaying hypnotically above me, until all I felt was the lethargy of dissolving limbs. Finally, after a suspension of time, she pulled me up, led me to the door, and motioned me out.

I hesitated. Somehow I had to acknowledge this intimacy, mercantile though it was.

"My name is Viviane."

"Istanbul!" She showed two gold teeth in an automatic, uncomprehending grin.

I wobbled back to my cubicle, lay down on the wooden cot, and fell into a facsimile of death. My next recollection was of the hostess knocking on the door, then entering, carrying a glass of hot tea on a brass tray. She sat on the edge of the cot, quietly amused at my lassitude.

While I dressed and sipped tea, the woman told me she had come from Russia in the early forties. She had remained in Istanbul, a voluntary exile from one culture and now living in two, a psychological straddle that mirrored the geography of this extraordinary city with one foot in Europe, the other in Asia.

Still in a languid dream state, I wondered aloud why she had

left Russia. Had the political or family exigencies brought her here? Why had she remained in Istanbul? Impertinent questions from a stranger, I suppose, although I noticed that Americans were forgiven many blunders. Yet she showed no annoyance.

Nor did she divulge anything. Instead, she questioned *me*. Why had I come to the Cağaloğlu Hamam? One rarely saw Americans here.

"My mother was born in Constantinople. She came here when she was a young girl. I wanted to get a sense of her life here, what it must have been like in her day."

"Ah." She nodded. Then she took hold of my hands and fixed me with her oracular Tartar eyes.

"Don't try so hard to *understand* Stamboul. It is too old, and has too many layers. Like an onion." Echoes of Jenny's comments fourteen years ago. "Just accept, then maybe she will show herself. Or [with a shrug] maybe she won't." She turned up the collar of my coat against the forbidding cold outside, and uttered the traditional Turkish goodbye, *"Güle güle"* (bon voyage), and then gave me a gentle shove out on to the street. Still bemused, still in the eighteenth century, I made my way back into the center of that twentieth-century paradox, Istanbul.

The Pierre Loti

THE PREVIOUS YEAR we had met Melahat through my cousin Yvette, who lived in Rome.

"You would be well served to meet her," said Yvette. "She and her husband are delightful people. They are visiting friends in Los Angeles."

They turned out to be a handsome and learned Turkish couple, with an openness of spirit that charmed us on the day we spent together. Now back in her homeland, Melahat offered her services for a day.

She possessed a profound but not uncritical love of her native city, and nerves of steel when dealing with the deadly business of driving in Istanbul, the best example I know of *inshallah* made patent. If one was meant to die in traffic, one would. If not....

Horns were meant to be leaned on. The subliminal theme of honking like so many angry geese was ever present in the continual symphony of traffic noises throughout the city. From what I could see, traffic signals could be and were routinely ignored. My husband, crossing the street on a green light one day, was bumped by the bent fender of a car driven by an impatient motorist—Move! Move! *Allahaismarladik* (we put ourselves in the hands of God), while normally used as a polite form of goodbye,

seemed particularly pertinent in this case. It was absolutely suicidal for a non-Istanbullu to get behind the wheel of a car!

"Tell me where you want to go, and I will take you there," said Melahat.

"Does the Pierre Loti still exist?" I referred to the hundred-year-old coffeehouse on the Golden Horn, which my maternal grandfather used to frequent regularly.

"Of course. One hundred years is nothing in Turkey!"

The next morning, after picking us up at the Yeşil Ev, Melahat maneuvered her way through the snarled traffic along the banks of the Golden Horn. Once known as the Sweet Waters of Europe, this Bosphorus-fed inlet had been banked by *yalis* set amid forests of cedar and pine. *Kayiks* (long, narrow rowboats) had been used to drift across its untainted waters. But when industry replaced the pastoral scene, the Golden Horn became Istanbul's sewer, a noxious, scummy, almost unnavigable body of water. Now the city was resolutely trying to reverse decades of pollution.

Shortly before arriving at the Pierre Loti, Melahat informed us she was going to make a detour. "We will make a little *haç* [pilgrimage] to Eyüp" (the Arabic name for Job, standard-bearer to Mohammed).

Known still as the "Holy Place," Eyüp was once a recognized stopping site for pilgrims on their way to Mecca. It was a lovely garden of a town, and today remains an enclave of devout Muslims living modestly in the midst of a multitude of mosques and cemeteries.

At the entrance to the town, on the left, a large and elaborate mosque, the Eyüp Camii, reigned amid the vines and weeds of its surrounding cemetery. The stone grave markers, when not toppled by soft earth or weather, were spotted with lichen and leaned to either side in crooked rows, like carefree, loopy souls.

The men's funerary markers were crowned with blowsy tur-
bans and fezzes; those of the women were topped with large-
petaled flowers. The airy delicacy of their Islamic calligraphy
created a sense of happiness rather than sorrow.

Such tombstones popped up in unexpected places through-
out the town. I spotted one in the middle of the main road; cars
simply drove around it. Like children anxious to be included in
activities and escaped, somehow, from cemetery constraints, they
looked surprisingly normal amid the usual staples of village life.

In the *kahueler* (coffeehouses), groups of seated men drank
coffee or tea, smoked *nargiles*, and played backgammon. On the
street, children in school uniforms darted in and out of lines like
noisy goslings, to the irritation of their teachers; women covered
their heads and faces against curious infidels. An old man bearing
a dozen *simits* on a dowel sang his wares. We stopped and bought
one before continuing up the Golden Horn.

Some few minutes up the highway, Melahat turned off to the
left and headed up a slight incline, then veered sharply right on a
steep, cobbled road for close to a mile, at the end of which the
road leveled off. She executed a calligraphic turn and headed
down a little lane toward the Pierre Loti. I was absolutely certain
that everything in Turkey—the birds, the minarets, even the
death-defying drivers—were subconsciously informed by the
grace of Islamic writing.

A few grave markers leaned pell-mell in the tall grasses. Had
my grandfather traveled that road by foot? By phaeton? He would
have had to take a *kayik* from Hasköy, the small village across the
estuary where he and his family lived among other Sephardic
Jews. It must have taken hours—but, of course, time was mea-
sured differently in the 1900s.

On the left, an old wooden house provided a kitchen for the
adjacent tea garden and salesroom for the usual assortment of

tourist fare—postcards, guidebooks to Istanbul in eight languages, copper vessels certified as antiques but hammered out only yesterday, painted plates with tulip motifs, blue beads that guaranteed protection against the evil eye even to the unbelieving. The café was on the right, in an area framed by venerable sycamores and pines. Small wooden tables and chairs were placed under a trellis embroidered with vines and strings of colored lights. Below that was an identical terrace, and a similar one below that. Seated atop a hill overlooking the Golden Horn, it offered a seductive invitation to while away an afternoon. This time-honored rendezvous for writers and poets had been named in honor of the French author Pierre Loti. Bewitched by his romantic vision of a mysterious Turkey and haremed *houris,* Loti wrote his most famous book, *Aziade,* while on a tour with the Navy, using Constantinople as his background.

My mother and Aunt Fortunée regarded this café as sacred, its importance determined by the fact that their father, my Grandfather David, had adopted it as "his" café around the beginning of the twentieth century. This beloved patriarch, whose ancestors had lived in Turkey since the 1500s, had been an editor and publisher of newspapers for fifty years. His last one, *El Tiempo (The Times),* originally in Hebrew, then translated into Ladino, served the large Sephardic population in the Levant and spoke with the voice of a staunch patriot. Grandfather David insisted, both aloud and in print, that the Jews, who had been granted sanctuary by Turkey since the 1500s, owed their host country loyalty. In practical terms, this meant signing up for military service.

For this frequently repudiated view, and for his impassioned stand against Zionism, his home was burned almost to the ground twice. He was forced into hiding, and was twice excommunicated by the rabbinate in Constantinople. He remained unswervingly committed to the idea of assimilation. I have wondered if he

would have held to his views had he lived during and after the
Holocaust, when the notion of a Jewish homeland promised safe-
ty to a beleaguered people. Undaunted, he continued to publish
his views, his sons frequently paying his loyal employees when
their father, his mind on more exalted matters, forgot to do so.
Meanwhile he taught himself French so he could follow events in
western European newspapers and translate poetry. His six sons
honored and admired him; his daughters placed him on a pedes-
tal from which he never, in their eyes, tumbled.

His marriage, born of a romantic impulse, became the sub-
ject of family legend. As a young unmarried woman my Grand-
mother Rebecca had been so impressed by a passionate essay the
young editor had written in his newspaper that she went secretly
and unescorted to his office to express her admiration—an act of
boldness unheard of in her time. Their subsequent marriage,
based on romantic love rather than family arrangement, lasted
until her death.

But now, more than a hundred years later, a large gray high-
way ran along the banks of the Golden Horn like a listless snake.
Occasional square buildings—factories, said Melahat—were scat-
tered beside it. Gone were the cedars and pines. Gone was the
tranquil landscape my grandfather must have gazed on. I felt a
sharp stab of disappointment. But that feeling wasn't new to me. I
had felt exactly the same way when I visited the cafés on Montpar-
nasse and St. Germain in Paris and the famous coffee houses in
Zurich and Vienna, cafés where, in the early part of the 1900s,
young writers and revolutionaries, unknown then but later fa-
mous, plotted their stories and insurrections. By the time I man-
aged to reach those celebrated places not a whiff of genius or dan-
ger clung to their walls. The walls had been painted and repaint-
ed long ago. At the former tables of Hemingway and Lenin and
Rilke, bourgeois ladies in fancy hats indulging in pastries had

replaced shabby intellectuals hunkered over their notebooks. What had I expected?

Still, a distinct peace prevailed here. We settled down at one of the tables covered with a blue-and-red checked cloth to drink tea in the dappled shade. The hum of traffic along the banks of the Golden Horn below began to fade. I heard instead the low murmur of voices of other patrons, the clink of their spoons stirring cubes of sugar in glasses of tea, the unforgettable auricular signature of Turkey. I sank imperceptibly into a languor, which Loti described as *"Un Turquerie delicieus"* (a delicious Turkishness) very much like my father's Sunday *keyif*. I could easily imagine my grandfather sitting here, talking, perhaps arguing, with his colleagues, then slipping into a similar reverie.

Some time later we heard a car drive up. We turned and saw a large chauffeur-driven automobile stop at the foot of the lane. An ancient uniformed driver got out and slowly opened the door for a young woman in western dress. She scanned the tables, then walked over to one at the end of the highest tier, two tables away from ours, where a clearing through the trees offered an unobstructed view of the Golden Horn. She sat down. The chauffeur followed behind her carrying an easel, canvas, and paints. She set up the equipment, then leaned forward and gazed intently for a long time at the scene below her. The old man bent over her shoulder. He stood very close, and murmured something we couldn't hear. Then she picked up a charcoal stick and with sure strokes began sketching the outlines of the inlet. As the landscape took shape and as she began to apply paint, we inched our chairs closer. The chauffeur never left her side, nor did he stop his murmuring.

The landscape the young woman was painting, ostensibly the same one we were looking at, had been transposed into another. The highway below had metamorphosed into a rural path beside

marbled quays. Cars had become horses and carriages. The non-descript factories had disappeared and in their place ornamented wooden *yalis* nestled gracefully among the cypresses. A few brightly colored *caiques* with curved beaks and dangling tassels skimmed atop the water like exotic dragonflies. The scene cast a singular spell.

Curiosity won over discretion. The three of us rose and walked hesitantly over to the painter. The old man bowed and withdrew to the shade of a pine tree. Melahat translated: we apologized for intruding, but were baffled that she was painting a scene that was invisible to us.

The young woman smiled and answered in English, "My chauffeur has been with our family for several generations. When I was a child he constantly told me stories of the old Constantinople, and it always seemed to me so much more beautiful than what I actually saw. When I grew up, we settled on an arrangement. Now he drives me and my canvases and paints to the places he remembers, and he 'talks' me into *his* landscapes. It's a wonderful way for me to discover the past and for him to recapture it. I think it's a good bargain, don't you?"

She was right, of course. Both views were "real." The ancient and the new were indivisible, making a pentimento of sorts, where the new faded to reveal the old beneath. I was slowly beginning to perceive that this dichotomy was the cornerstone of the complexity of Turkey. It seemed only natural to shed rigid delineations of old and new; to think, instead, in terms of a seamless continuum.

So that when Melahat deposited us at the Yeşil Ev in the old Sultanhamet quarter, where twentieth-century traffic swirled around the sixteenth-century Aya Sofia and where young men hawked old rugs, it all seemed perfectly normal.

The last time we had seen Berto he had asked me, but only half-jokingly, if we had bought a rug yet, and if not, why not?

"No one can possibly leave Turkey without buying a rug! And you, of all people…!"

Finally I recognized that the time had come. Time to buy a rug. At what point had I shed my initial mistrust? By what process had I finally arrived at a level of comfort in the presence of rug dealers? Maybe it was the repeated exposure to rugs in shops, rugs on the street, or my visit to the rug store in the bazaar.

In any case, when Melahat drove off, we simply headed like homing pigeons to a circular building called Haseki Hürrem Hamami (Turkish Handwoven Carpets), the former bathhouse of Roxelana, the beloved wife of Suleyman the Magnificent. It was located between the Aya Sofia and our hotel. The building had been converted into what appeared to be a rug museum. It seemed a good place to start. Inside we found an astonishingly rich display of hand-woven carpets from all areas of Turkey.

This *had* to be a museum, not a place of commerce. Looking around, we noted an absence of scattered floor pillows or groups of seated men. No one asked for my husband's business card. There was no pressure to buy.

We wandered through the niched and circular rooms and gazed at the collection. There were carpets here whose designs originated in Konya, Hereke, Kirşehir Ladik, and Gördes, each representative of its specific area and displaying woven depictions of elaborate floral gardens and intricate geometric designs.

But it was to the rugs of Bergama that we kept returning— those rugs with geometric designs—and in particular to one woven in rich hues of sienna and deep midnight blue. We went up to the receptionist, who, until now, had kept discretely away, to ask more about it.

"Do you wish to buy it?"

We stared back at her. "The rugs are for sale?"

"Absolutely."

The government, she explained, was concerned about losing the designs of carpets woven in Turkey for hundreds of years and so had instituted a ten-year project of preservation. The designs of these classical rugs, taken from private collections and museums throughout the world, had been laboriously gathered, identified, and transferred onto computers. These rugs had been made by weavers in Anatolia, who copied the computer designs and incorporated their own slight variations.

"Exactly like that particular Bergama in which you are interested," said the receptionist. She reached into her desk and brought out a computer design of the original carpet. We compared it to the one on display: there were subtle variations in color and design, but its family connection was indisputable.

"And do you want that particular Bergama?"

Yes, we wanted it.

Woven in 1986 by one twenty-year-old Fatima Jeybeli from Nevşehir, in Cappadocia, its original design dated from the nine-tenth century and was conceived in Bergama, the site of old Pergamon.

This time no little boy ran out for tea. There was no obligatory exchange of personal information. The transaction came down simply to our money for their rug, at a price that was rigidly controlled by the government. The receptionist folded up the rug with efficiency born of long experience. She wrapped paper around it, tied it with a cord, and handed it to my husband, who put it under one arm and walked off like any other Turk who had partaken in an honorable trade.

And like the rug of any other Turk, it would travel with us — in this case, along the Aegean and into Anatolia.

Silent Stones

IN ISTANBUL ONE'S MIND is split by the clash of two cultures. But such is not the case along the Aegean, that astonishingly beautiful stretch of coast that, by history and culture, belonged to Greece. It was to the Aegean that we headed, propelled by Jenny's directive.

We were determined to do the driving ourselves, although my husband had categorically refused to drive in Istanbul saying, "We might as well sign our death warrant!" He was adamant with the man from the car rental agency. If he could be guaranteed the delivery of a car at the outskirts of Istanbul, he would rent it; otherwise, he wouldn't.

"No problem," said the man from the agency. He picked us up at the Yeşil Ev, while his cousin (I no longer questioned kinship) drove behind us across the graceful arch of the Bosphorus bridge to the Anatolian side. He deposited us at another rental agency, then drove away in the cousin's car.

The owner presented us with a beat-up sedan that had a broken radio and a windshield half-obscured by bird droppings. He cleaned the window with a dirty rag, then banged on the fender and sent us lurching off toward the Sea of Marmara.

We were pleasantly surprised. Once away from Istanbul, the two-lane roads were good, and so were the signs. The trick, however, was to gauge the intent of the drivers directly ahead, all

of whom appeared to be driving trucks the size of oceanliners. Their belches of black diesel smoke obliterated everything in sight. The drivers were courteous—they waved us on—but their sense of distance was myopic at best, suicidal at worst. More than once as we skirted an enormous truck, we were horrified to see a car bearing directly down on us from the opposite direction, the driver's hand cemented to the horn.

The driving became easier as my husband became bolder. Also, the farther away from Istanbul we got, the cleaner the air became. Some six hours later, after a tea stop in the former capital of the Ottomans, Bursa, we came to a sharp bend in the road. Around the corner were the Dardanelles and the beginning of the Aegean coast. On our right, dark-blue waters; on our left, repudiating rocky cliffs.

We stopped at this juncture of history, literature, and myth. It was here, at the Dardanelles, that Atatürk's ultimate reputation was solidified in the Battle of Gallipoli, which he fought and won on this blood-stained peninsula.

It was here that Leander nightly swam the Hellespont, guided by the lamp of his beloved Hero, Priestess of Aphrodite, in Christopher Marlowe's poem. It was here that Byron swam that same narrow strait in 1810 in honor of Marlowe's lovestruck figure of literature.

We heard a low moaning. "The ghost of Hero," I announced, wedded to the fanciful.

"Cows," said my husband. He pointed to an approaching herd, preceded by three goats, clambering down the road around the bend. A cape-clad, leather-faced man with one milky eye trudged along beside them, humming some sweet low song of pain and loss. We stopped the car, and I got out and walked toward him and his cows and touched the warm, sweaty flank of one, who slowly turned a lackluster eye in my direction.

I nodded to the herdsman. *"Merhaba"* (Hello).

The man bowed solemnly. Then he reached out for my hand, took it in his two rough ones, raised it to his cracked lips and kissed it with infinite delicacy. He held out a beaten canteen and motioned for me to drink. I did so, recognizing the warm, acrid taste of goat's milk. I thanked him. The herdsman took up his song again and nudged his animals along, and we turned the corner to the Aegean.

Here, at last, was Homer's "wine-dark sea," the home of the Dorians, the Aeolians, and the Ionians, Greek colonists who, fleeing the Peloponnesian Wars, settled along the whole of the Asiatic coast and permanently altered the culture of Turkey.

A short drive along the Aegean brought us to Assos. Before we left Istanbul, Nevzat had urged us to stop here. His wife, Sabrina, and their daughter, Lara, were staying there while Sabrina oversaw the building of their vacation home. And so we spent the night in that small town on the north shore of the tranquil Gulf of Edermi, where the mist-shrouded island of Lesbos slumbered in the distance.

The seaside hotel, below the ancient site of Assos's acropolis, was a sprawling business with minimal comforts and negligent service. It was overrun by the owner's gargantuan dogs. He continually washed one mastiff, two great danes, and another dog of dubious parentage in a large pentagonal fountain in the front of the hotel. The fountain splashed night and day, to the delight of the dogs, who jumped in and out of the water constantly, barking, shaking their enormous bodies, and thoroughly drenching their owner, who considered it great sport.

The needs of the few guests at the hotel were attended to only after the dogs, soaked and spent, their lolling tongues flecked with foam, flopped down on the ground. It was the one and only time in Turkey I witnessed great affection between man and dog.

That evening, Nevzat, having just arrived from Istanbul, came to fetch us. For the space of those few hours, we might just as easily have been sitting along the shores of the Bosphorus. There was the same gentle lapping of water along the stones of the little seafood restaurant where propriatary cats held reign, the same menu of sweet, fresh fish and white wine, and the same sense of timelessness.

This Nevzat, years away from the handsome but unsure young man we'd met in 1977, still handsome, was now a uxorious paterfamilias. I liked his Sabrina immediately. I liked the flash of her smile and her fierce independence, and saw those qualities mirrored in their nine-year-old daughter Lara, who assumed the world existed only to give her pleasure; to date, she had seen no reason to think otherwise.

In the apricot dawn of the following morning, I tiptoed out of our room and down to the sea. There was no sign of life except for the dogs, who apparently never slept. I removed my nightshirt, dropped it on the rocks, and dove into the lucid Aegean, followed by the dogs. They splashed after me, barking their joy, drooling and slashing the water with their tails. The mastiff, who obviously thought this was a great game, stole my shirt. He clamped his yellow fangs around it and plunged into the water. I barely won the tussle.

After the swim, some barbarous coffee sent us off along a winding drive through domesticated groves of silver olive trees and fig trees swollen with their burden of fruit, to Troy—ancient Ilium.

At the front of the site an enormous, ridiculous-looking wooden Trojan horse had been erected. I found it offensive, and somehow insulting. It had the effect of reducing this historic and literary city to an amusement park. So I concentrated instead on the poets whose spirits were everywhere here—Byron, Virgil, Homer—

grateful that their faces were not reproduced in enormous dioramas.

Homer's *Iliad* and *Odyssey* informed the western psyche since the eighth century B.C. His words were responsible for one of the world's most astonishing archaeological digs. The excavation of Troy, layer after layer, was the direct result of Heinrich Schliemann's unquestioning belief in the poet's tale and his determination to uncover the fabled city.

Once we were past the gracefully proportioned Mycenean walls of Troy VI, I had the impression that I was walking in the middle of an archaeological graveyard. My fanciful conceit about ancient stones was that the frozen history within them contained a secret language. If I could decode them, the stones would speak to me—in this case, in the voices of Helen and Paris and Menelaus, voices of literature for the West, but voices very real to the ancient Greeks. They didn't speak, of course—or else I failed to hear them. I couldn't repopulate Troy. To my great disappointment, Ilium remained impenetrable.

I wandered about in the dirt and scrub, among the fallen plinths and pediments of so many ruined cities, reading the scant markings that told too little about the fragments from various excavated Troys, and bemoaned the fact that I had never read the *Iliad*. Finally I sat down on a tumbled column and gazed out across that dun-colored land, Tennyson's "ringing plains of windy Troy." I longed for my father, convinced he could have unlocked the magic of Troy for me.

My father was a lover of ancient tales. Where had he developed his taste for them, having come so young to America? Or did that come later, in Palestine? Whenever he was moved by the beauty or breadth of classic writings, he would read them aloud to me and animate the antique scenes with his passion. It was one of the pleasures of my young life.

But I was a lazy girl, and thus a lazy scholar. Instead of being propelled to further reading on my own, I simply basked in the theatrics of his delivery. So the slight wisp of magic I felt as I looked out over those plains I attributed to the ghost of my father as much as to that of a credulous Schliemann, who had looked out on this same scene and proclaimed it Troy.

We had read that Pergamon, today's Bergama, would be more generous with her remains, and so continued driving south from Troy toward that ancient Hellenic city-state. By now a merciless blanket of heat shrouded the road. Our car, baptized the *Inshallah*, lacked air conditioning, so we opened the windows to let in blasts of hot air.

Without warning, we were forced to a halt by a long line of cars stopped dead ahead. All we could see was some sort of overhang under which each car stopped, then went on. Passport control? A checkpoint for some obscure regulation? It was neither. It was, instead, one of those welcome water gifts that Turks and desert nomads have the courtesy to offer. As we came closer, we saw that it was a car shower!

We drove under the overhang, which was equipped with a number of spigots that rained water down onto the car, both cleaning and cooling it—a benevolent invention of a people who provide basins and fountains everywhere and consider water a blessing to be shared by all.

At the outskirts of Bergama a long, winding pine-flanked road led to the superb isolation of the citadel, perched 1,300 feet above the plain. Here, at the acropolis, of which only the foundation remained, had dwelt the kings Eumenes, Attalus, and others. Here as well was the theater, an acrophobe's nightmare, carved into a hillside so steep I was forced to walk down the aisles leaning backwards so as not to plummet forward.

Almost nothing remained of the great library begun by Attalus II, save its tantalizing history. The Egyptians, concerned that the 200,000 papyrus scrolls housed in the Pergamon library rivaled their collection in the famous Alexandrian library, banned the export of papyrus to the Pergamenes.

So these undaunted heirs of Alexander simply renewed the ancient custom of writing on dried skins—parchment—which became known as pergamon. Since parchment could not be rolled, the form of the modern book was born.

We roamed among the foundations and columns of ancient temples, altars, and palaces, stone skeletons of a city that once had been a cultural rival of Athens. Where, I asked, was the superb altar of Zeus? In Berlin, I learned. And the great marble heads of Trajan and Alexander? In Berlin, as well. The more I read my guidebook, the more it vexed me to think that Pergamon's greatest glories inhabited the Pergamon Museum in East Berlin. An injustice, if not an outright theft, I ranted aloud to the sky and to anyone who would listen, even though I knew nothing of the circumstances. My indignation was partly the result of the sun, which beat down on my hatless head. Two tourists close by stared at me suspiciously, then quickly walked away—crazy woman. I wanted to leave.

But my husband insisted on seeing the Aesculapion, the greatest Anatolian medical sanctuary of its time. It was here, at the edge of the modern city of Bergama, that the famed Greek physician Galen practiced methods of healing in the first century A.D. that could, without apology, take their places next to some of our modern psychological treatments.

We found ourselves sandwiched between two tours as we began exploring the Aesculapion. Ahead of us was a German group. Large men hung with cameras wore shorts and sturdy sandals; the women wore sleeveless print dresses and solid shoes. All of them

wore hats. Very sensible. The tour guide, his face turned beet-red from the pitiless sun, strode ahead of the group, shouting dates and events over his shoulder, his Michelin guide firmly in hand. His charges obediently opened their guidebooks to page whatever, and nodded.

"*Im Jahre...*" (In the year) and "*Daraus folgt...*" (From that it follows...) rang across the plains.

A French tour straggled behind us, blithely lacking in discipline. The guide, who seemed totally unconcerned with the formality of rank, wove in and out between the members of his tour, making jokes. He finally cajoled his unruly flock, "*Alons, mes amies...l'histoire nous attendes!*" (Come along, my friends... history awaits us!) The women had removed their hats and were using them as fans. Most of the men had shed their shirts and were wandering about in undershirts, wiping their sweaty faces and underarms with crumpled handkerchiefs. They good-naturedly swarmed around us and ahead. "*Pardon! Pardon!*"

We followed them into the Sacred Tunnel, a 226-foot-long passageway in the middle of the sanctuary, evolved from the ancient ritual of incubation, developed by Egyptians in the third millennium B.C. for the purpose of diagnosing illnesses through dreams. Channels on both sides of the inner passageway allowed water to flow the length of the tunnel, keeping it cool. Every few yards grates had been cut into the ceiling, over which priest/doctors had once lain, murmuring suggestions to the sleeping patients below. Upon waking, the patients consulted these same sages, who then interpreted their dreams and prescribed treatment—a remarkably effective psychological loop!

The genial rooster of a French guide, having coaxed his unruly brood into the semblance of a line, explained the tunnel's purpose. Suddenly, one of the men broke loose, darted off in a frenzied run, then stopped, turned and raised his arms to heaven and

cried out with the fervor of an epileptic, *"Je suis gueri!"* (I am cured!)

"It will take more than this, Albert!" a member of the group called out. Whoops of good-natured laughter erupted. The German tour, which had preceded them, turned as one body and scowled. This was serious business—it was not funny.

We stayed overnight in Izmir, Turkey's largest city on the Aegean, and my father's birthplace. His only mention of it that I could recall was his insistence that the figs of Smyrna, as the city was called in his day, were superior to those found anywhere else in the world.

"Figs from the looms of Smyrna…" he would muse, his eyes distant. And since he was not given to hyperbole, I believed him. Was it from him that I inherited a love for that fruit? Could a particular taste be genetically transmitted?

Now, driving around the city, I wondered where my father had lived and whether, in fact, the neighborhood still existed. Probably it was around Bikur Holim, the synagogue still in use along Havra Sokak (the Street of the Synagogues), but I had no clue where to begin.

Of the nearly 50,000 Jews who populated Smyrna in the 1700s, only 1,800 remained. But my father had left long before the two seminal events that altered forever the character of Smyrna. The first was a devastating fire in 1922.

It was the fault of the Greeks, claimed those who mistrusted them, or the fault of the Armenians, claimed some disgruntled Turks; both were distrusted minorities that frequently bore the brunt of Turkish suspicion.

Then, the following year, the Treaty of Lausanne had mandated a massive exchange of populations. The Greeks in Smyrna, who were the majority of the inhabitants, were resettled in their

homeland, and the Turks living in Greece were returned to theirs. It was a simple concept, but it proved to be not so simple in practice. Overlaps of populations still exist today in both countries.

The next morning we drove south to Selçuk, a little city that serves to whet one's appetite with a gem of a museum housing the excavated glories of Ephesus, just a few miles away. We walked in, followed by a rogue rooster who demanded obeisance. He strutted into the center of the entrance hall, stretched his iridescent feathered neck, and let out a crow to rival the cocks of Attica.

What I saw made me feel like doing the same. There, in only eight rooms, was a breathtaking collection of marble heads, coins, vases, and sculptures both noble and ribald from Ephesus, a city that is deemed one of the Seven Wonders of the World. Dominating it all was the "Great Artemis," a white marble adaptation of the cult statue at Ephesus, the mother-goddess figure whose predecessor was prevalent in Anatolia throughout prehistoric times.

Once we were in Ephesus, the purgatorial rug salesmen swooped down on us. A pleading Gypsy held on to a shaggy iron-shackled bear, plucked at my sleeve with his other hand, and whined, "Take picture with bear!" Purveyors of watermelons had arranged their wares on the ground in green and pink pyramids. A cluster of uniformed guides attacked us like angry wasps. They shoved and elbowed each other.

"You want English guide? I am official guide…see pin? Only twenty-five dollars."

My husband skirted them all and instead found Jacob, an archaeology student at a local college, to the disgust of an official guide who snarled, "He not official!" He spat on the ground and strode away, a gesture I found shocking from one of the usually courteous Turks.

The "unofficial" Jacob was a font of knowledge, all youthful passion spent on ancient stone. His dream, he told us, was to find

an unexplored treasure—a fragment, an urn, it didn't matter. For the present he worked as a guide at Ephesus. When he spoke of Cybele and Artemis, and about the apostle John, and about St. Paul, who came to convert the tenth-century citizens who had lived in the largest commercial and religious center in Asia Minor, he might have been chatting about members of his family, he knew them so well.

Jacob led us along the Marble Road to the Celsus Library, with sculptures on the capitals that rivaled embroidery and book niches that seemed only recently emptied. He took us to the majestic theater carved into the side of Mt. Pion—three levels with an ornate façade and a seating capacity of 24,000. For five full hours, with no break for food, we followed Jacob from relic to ruins, to the baths of Scholastica, to temples, and to cemeteries. He talked the whole time, almost without punctuation, earnest and informative, until I finally lost my wit.

I was steeped in antiquity; dizzy from trying to remember which peoples had occupied which sites and when, whence they came and why, and so on. Names scrambled around inside my skull like gerbils in a cage—Carians, Lydians, Aeolians, Dorians, Troads, Chalcedonians, Macedonians.... I called an abrupt halt, to Jacob's keen disappointment:

"But you can't stop now; I have so much more to show you!"

We mumbled apologies, scuttling away like truants from school, and drove down the coast to the popular resort of Kuşadasi. Our hotel, an elaborately modern affair that had almost nothing to do with Turkish culture and everything to do with tourist luxury, was perched on a steep peninsula at the northern end of town.

We were extravagantly fed and bedded. We swam in the turquoise water of the port and snacked on watermelon and feta cheese in the little town. I indulged in "figs from the looms of

Smyrna" and proclaimed my father correct—they were absolutely ambrosial!

I put away the guidebooks and simply thought about what we had seen along the Aegean coast. We drank countless cups of coffee in tiny sidewalk cafes in the bazaar and watched the Byzantine manipulations of Oriental commerce unfold before us, in scenes probably unchanged for centuries.

It was here in Kuşadasi, over a period of three days, that I recovered my serenity before heading for Bodrum—the ancient Halicarnassus—and the beginning of our Anatolian exploration.

Anatolia

OUR ITINERARY READ, "In Bodrum you will find Aydin and a comfortable car. He will be your driver and guide through Anatolia." But some misery had befallen Aydin. He had been replaced by Ibrahim, a sweet, plump young man barely weaned from mother's milk. He introduced us to Anna, his shy and silent fiancée—she uttered not a word to us during the entire drive across Anatolia—and the puzzle of how to fit their four and our three suitcases in the trunk of the small, battered Renault parked along Bodrum's boardwalk.

The inside of the car was festooned, as though in preparation for a Middle Eastern carnival. Purple balled fringe outlined the windows; a blue "evil eye" bead and a plastic cross adorned with a lumpish Jesus hung from the mirror; both the front and back floorboards were covered with Turkish carpets the color of a port wine stain. A glass vase exploding with a clump of faux roses was affixed to the dashboard.

The four of us began shoving and squeezing the suitcases into the woefully inadequate trunk, then Ibrahim stood up, sweat pouring down his chubby face. "Please! Go have cup of tea. Tirty minutes, I will find place for everyting. No hurry. Is Turkey!"

When we returned, he had managed to crush all our belongings into the trunk, with the exception of two faded kilim pillows

and a rolled-up moth-eaten carpet with which we shared the back seat. Lacking only noisy livestock and a mattress tied to the roof of the car, we bucketed off while the silent Anna lovingly wiped her perspiring fiancée's neck with a handkerchief dipped in Limon.

Almost immediately we turned our backs to the Aegean and rose up from the coast into the Taurus Mountains, Turkey's massive southern chain of mountains that stand militarily erect like pine-covered soldiers. Several hours later, when the sea reappeared, we were on the Mediterranean, in Fethiye, a small town settled by Lycians, a native Anatolian people going back to the seventh century B.C.

Fethiye's ancient kings, loathe to relinquish their power even in death, had their royal tombs carved into the sheer rocks above the town, with the result that, in an eerie way, their imperial presence continued to dominate centuries later. They watched over Fetiye still.

"How old are these tombs?" I asked Ibrahim.

His forehead furrowed with heavy import. "Oh," he intoned, "A *tousand years!*"

With his answer came our first doubts about his knowledge of ancient history. It was murky, at best, despite his claim that "I graduate with honor from Guide School in Istanbul!" From then on, the age of any and all points of interest, be they architectural, historical, or natural, was "A *tousand years!*"

Like a nimble goat, I clambered up some hundred vertiginous stone steps among the weeds to the largest of those elaborately carved mortuary façades. The view from there was tranquil. Fethiye's lovely little harbor, garlanded by twelve islets, basked peacefully in the azure Mediterranean—the Olu Deniz (Dead Sea) so named for its lack of waves—under the blind gaze of spectral sentinels.

Here, high above the city, at the edge of a dark space that had

once contained the remains of kings—a maw that fairly vibrated with mystery—I heard a rustling. I crept up to that sunless hole with more than a little dread and found—a scrawny chicken. Ignorant of history, it had climbed up into the vacant tomb and was scratching among the weeds.

I laughed aloud, partly from relief. But the empty tomb struck a dark memory of my Uncle Mauricio's burial so strongly that I felt it physically. I sat down on a rock and forced myself to evoke the shocking recollection.

At the age of forty-five after years of numerous romances, my uncle had married Dotti, a four-months-pregnant blond Canadian Juno in her mid-twenties. She bore him a beautiful, dark-haired daughter, Ana-Maria. A second pregnancy produced another daughter, Jacqueline, who was diagnosed as Mongoloid (as they called Down Syndrome babies then); the doctors predicted she would never function above the capacity of a five-year-old child. Time proved them correct.

And then Dotti disappeared with her female lover. Mauricio was stunned and perplexed. He had had no idea, he wrote his sisters, his letter full of anguished self-examination. Could he have prevented it? Were indications there before, and if so, why had he not heeded them? He hired detectives, but she had vanished, never to be found.

From that day on, Mauricio lost his former ebullience to a progressive obsession about Jacqueline's fate. Who would care for her when he died? His large house on Paseo da la Reforma, which had welcomed all the writers, politicians, and artists of Mexico City, became dark and solitary. As full of adventures as had been the first half of the life of my diplomat/journalist/bon vivant uncle, equally despairing was the second half.

When Mauricio turned sixty-five, the young maid whom he had hired to care for Jacqueline proposed that he marry her and

give her a child and his name, in exchange for which she promised to care for Jacqueline until the end of her life. Weary and seeing no other option, he agreed. A year later his son, Mauricio, was born. Five years later, my uncle suffered a stroke and died.

Even though I would only be able to stay for twenty-four hours, I felt the urgent need to attend the funeral of this uncle who had brought so much into my young life. He had left instructions that he be cremated and that his ashes be scattered in the forest outside of the city he loved, Mexico. Ana, now a grown woman, picked me up at the airport, and we sat in her apartment looking at photos and sharing memories of her father, my uncle, which finally fused into one intense, loving, and difficult man recognizable to us both.

The next morning we were driven in a hearse, my uncle's coffin smothered by arrangements of white gladiolas and lilies, to the outskirts of the city on pot-holed roads. Two hours later we stopped in front of a gray cement building with a smokestack— the crematorium. In this most Catholic of countries, the heretical offense had been placed as far from view as possible. Waiting for us in a squalid room were Mauricio's widow, Berta, her sister, and Octavio Colmenares, Mauricio's friend.

Four dour young men removed the coffin from the hearse, brought it into the building, and deposited it with a loud thump onto the cement floor. Their disapproval was manifest. They flung the flowers aside and brusquely opened the coffin to expose the body.

The corpse was unexpectedly small, clad still in hospital pyjamas, with one hand drawn up in a claw-like position. Behind the head, which rested on a puckered satin pillow, was a halo of dried blood.

Colmenares stepped forward; we all drew toward him and surrounded the casket. He began to speak about his friend—of his

integrity, his loyalty, his passion for justice—and asked that my uncle's troubled soul might finally be at rest. We all, believers and non-believers, murmured, "Amen."

On hearing that word, the four men stepped forward. Suddenly the iron door on the opposite wall slid open, revealing an inferno of flames. In one angry movement they picked up the body from the casket and flung it, head first, into the furnace. The iron door slid shut. Berta screamed. Ana's body was gripped by waves of spasms. I held her until they stopped.

We sat down on the penitential chairs against the wall and began our wait. Mexican law prohibits the "responsible" party from leaving until the cremation is finished and the ashes handed to that person. It would be many hours.

I walked outside with Colmenares, through abandoned graves among weeds. "What an ignoble end for such a generous man," said Colmenares. "He helped so many. When he was consul in Bordeaux during the war he helped thousands of refugees in the Pyrenees escape to Mexico, did you know that? Where were they, his friends, when he needed them?" The man's finely etched face was suffused with outrage.

I returned to the room. Ana sat in glacial silence. Despite my mediocre Spanish, which lacked all subtleties, I tried to talk to Berta; her polite responses barely concealed a bedrock of suspicion. Was I going to impose some familial demand? Why had I come?

The fruit of this misguided attempt at communication was my request that she keep in touch. Yes, she said, yes, of course. We both knew she wouldn't. Nor did she. She, like Dotti, disappeared forever, and with her, Mauricio's son.

Suddenly Berta dashed across the room, entered a small door beside the furnace, and disappeared. In a few moments she reappeared, a look of stark terror on her face. "*¡Está quemando! ¡Está quemando! ¡He visto sus pies!*" (He's burning! He's burning! I saw

his feet!) She flung herself back in the chair, threw her black shawl over her head, and rocked back and forth, keening. Ana sat without looking at her, her face a wound.

Abruptly I realized that if I stayed any longer I would miss my plane. Ana assured me she would stay to the end, that she would take her father's ashes and scatter them in the forest. We held each other tightly, wordlessly. I was driven to the airport, where once I was on the plane, tears began to run down my face—the bitter salt of bereavement for my fine uncle.

I must have sat for a long time among the weeds below the royal tombs of Fetiye, lost in my memories, because it was with a shock that I suddenly heard my husband and Ibrahim calling. I shook off the past, along with the dust, and descended the hill.

Rather than follow the coast, Ibrahim insisted we drive the "beautiful way—only tree more hours" back through the massive Taurus Mountains to Antalya. We reached the city in the purple evening, just as a necklace of lights began to adorn the town. And here, what Ibrahim so sorely lacked as a guide, he made up for as a driver.

He expertly navigated the Renault along roads meant only for goats, weaving through a strangulation of pedestrians and drivers in the old town inside the ancient city walls. Fretted Ottoman houses faced each other, their balconies so close one could reach out to those across the narrow, cobbled streets.

Antalya was alive at night with the lap and hiss of water caressing the stones of the old port, with the clatter of dishes inside the restaurants lining its crescent, and with the pulsating music that splashed out from the cafés into the streets. We stopped to buy some pistachios from a dark, ferocious-looking man hawking his wares on the quay.

I pointed to a bag of nuts. He handed it to me, and I handed him some lira and thanked him: *"Tesekkür ederim."*

He shook his head and muttered something I couldn't understand. Abruptly, he reached out and clamped my wrist with his hand. He held it in a vise-like grip and growled, in raspy English, "I say 'thank you' in Kurdish—*not* Turkish. Not same language. *I am Kurd! Remember you meet Kurd in Antalya!*"

We ate the stale pistachios down to the last nut, like obedient children compelled by fear of God-knows-what punishment. The man's fierceness and the violence of his speech were like an electric shock in the balmy evening, a threat and an omen of events to come.

Ask an "Istanbullu" about the "Kurdish problem"—twenty percent of the population, approximately, are Kurds—and he will answer you with barely contained anger, "But they are Turks! They have all the rights of Turkish citizens. They even hold high positions in the government! Look at the former Prime Minister Ozal! What else do they want?"

Still, like a menacing ostinato, despite worldwide human rights reports, the army's destruction of Kurdish villages continued, as did bloody reprisals from the PKK, the Kurdish Workers Party. Ibrahim's response to our questions about the Kurds was deliberately vague. The subject made him uncomfortable.

Until now, despite their underlying Oriental propensities, the Greco-Roman coastal cities had offered sufficient western amenities to pacify most tourists. But once we left Antalya and headed northeast, the suddenly sullen Taurus Mountains took on the face of a bleak and leached landscape, although in its deep, igneous heart it held a wealth of minerals—copper, silver, lignite, zinc, and arsenic. Nothing appeared to live in this harsh, rocky region save thistles and black satyr-goats who munched on spiked plants without closing their evil yellow eyes. From this desolation we began a slow wind down the flanks of the Taurus Mountains, and dropped at last onto the steppes of Asia Minor in southwest Anatolia.

It was an historical descent as well. We were going back some eight hundred years to the Empire of the Selçuklular who arrived in 1097, into their capital, Konya. Somewhere along these austere miles, Ibrahim's mood began to change. No longer a good-humored romantic, he became churlish. Despite our pre-determined itinerary, we discovered by chance that he intended to by-pass Konya without telling us, and go directly to Cappadocia. But we insisted he stop in Konya—Iconium to the Greeks and Romans, the Empire of Rum to the Selçuklular. He did so with bad grace and without apology. He loathed Konya.

I had read somewhere a description of Konya as "One of the cleanest and best-kept cities in Turkey." Perhaps, but that was certainly not what I saw. Sullenly fulfilling his duty as guide, Ibrahim drove us around the circular Alaeddin Bulvari around Konya's citadel of great antiquity. "Here is center." As far as I could tell, what seemed most to unsettle his mind was being in the nucleus of Fundamentalist Islam.

The area of the city where Ibrahim deposited us, near the noisy jumble of a large outdoor food market, was almost unrelievedy shabby. No grace notes, no lacy balconies of wood, just concrete. I wondered if he had dropped us there deliberately, to prove his assessment of Konya correct. And yet the place throbbed with life.

After dropping off our bags at the hotel, we were drawn back to the market. The smell of coffee, tobacco, horse dung, and the stink of diesel fumes from the old cars that rattled and banged down the rutted streets mixed with the violent reek of blood from recently slaughtered animals in the open stalls. Great sheep carcasses hung on hooks, their eyes turned to glass, bleeding into rusty buckets, the whole scene reminiscent of the paintings by the anguished Chaim Soutine. I was horrified, but unable to look away.

From there we went to the home and shrine of Celâleddin Rumi, known to Muslims as Mevlâna—the Lord. The Sufic poet and mystic had escaped from northern Afghanistan to this city that was a refuge for artists and scholars during the twelfth and thirteenth centuries.

Part of Rumi's fame came from his having written the longest poem in the world, some 25,000 couplets, and part from the fact that he was an inspired mystic: He was the driving force behind the formation of Turkish Sufism, which included the Mevlâna sect of "Whirling Dervishes."

At the entrance to his tomb was engraved:

COME, COME AGAIN, WHOEVER,
WHATEVER YOU MAY BE, COME.
HEATHEN FIRE-WORSHIPPER
SINFUL OF IDOLATRY, COME.
COME EVEN IF YOU HAVE BROKEN
YOUR PENITENCE A HUNDRED TIMES.
OURS IS NOT THE PORTAL OF DESPAIR
AND MISERY, COME.

Reading it there gave me another memory-jolt. When my mother died, I inherited my father's small but catholic collection of books, as well as hers. Among his books of poetry, which also included Tagore and Homer, was a volume of poems by Rumi, translated into English from the original Persian. One could understand, given the poet's message of universal love, that his followers included Christians and Jews as well as Muslims.

To Ibrahim, Konya was no more than a sink of idolatrous belief. It was a total negation of the uncompromising anti-religious policies of Atatürk, who had dissolved the *tekkeler* (Dervish centers) of whirling Dervishes, whispering Dervishes, and shouting

Dervishes, where trance-like whirling dances were performed through which the spirit of God was believed to be conveyed via the dancers. Also, the Dervishes' increasing political power was more than Atatürk could countenance.

"They are mad-heads! *Delibaşilar!*" shouted Ibrahim to the indifferent landscape.

Atatürk, by providential historic timing, by dint of his military reputation cemented at Gallipoli, and by the sheer force of his magnetic personality, had propelled his countrymen, leaderless and spent after the devastation of World War I, into a secular twentieth century. His decrees: no more fezzes, no more veils, no more polygamy. He mandated the use of a common language, Osmanli; use of the Roman Alphabet; and equal rights for women, as well as strict separatism between church and state. *This* was a hero to Ibrahim.

Given Ibrahim's profound aversion to Konya, we all agreed that he would drop us off at our hotel and disappear with Anna until the next afternoon, while we visited the Mevlâna complex, the brilliant turquoise-tiled building containing the *turbeh* (tomb) of Rumi. The building served as a repository, as well, for elaborate silk embroideries replete with golden threads, priceless rugs of such decrepitude that many of the designs had faded, leaving only one's imagination to fill in the spaces, and examples of the willowy Sufic calligraphy writ huge—all of it illuminated by chandeliers plunging down from the ceiling like giant stalactites.

The complex was churning and noisy. The clamor of a bumping throng of tourists herded by German, French, Italian, and Japanese guides was overlaid by the hypnotic whine of the *ney* (Turkish flute) heard over loudspeakers. With all of that, it was primarily a place of pilgrimage and outpouring of religious fervor. Women with kerchiefed heads and men with wispy white beards, all dressed in black, moved like slow, dark clouds towards the

sloping tomb of Mevlâna. His sarcophagus, carved of wood, assembled without nails, and engraved with his mystic poetry, was covered in red, green, and golden cloth and topped with a giant turban.

The faithful knelt, held out their cupped hands, then brought them back, as though washing their faces with prayers. Completely oblivious of the milling tourists, they continued their devotional shuffle through the complex, weeping silently. How long could such emotional power be reined in? Already, like an irresistible ocean swell, it was beginning to push at the psychological and economic borders of the country. How would it express itself throughout the rest of secular Turkey? One of the ways would have to be political, I thought. Already Anatolian peasants were flocking daily into Istanbul at an overwhelming rate, bringing into their *Gecekondular* (neighborhoods of squatters' shacks that sprang up overnight) their fundamentalist Islamic beliefs and rural habits. East and West were smacking up against each other with the force of a tectonic collision.

We spent the night in a hotel we dubbed Camp Waconda, as it was reminiscent of Girl Scout accommodations. Our room had two narrow cots, a bureau with drawers that clattered to the floor when pulled out, and one broken chair. Ibrahim had dropped us off there after claiming the hotel on our itinerary was full. Really? I gave in to an uncharitable thought: Had he switched hotels and put us in this miserable place instead? Another example of anti-Konya propaganda?

The next morning we wandered the neighborhood, looking for souvenirs to bring home to our children. We passed darkened rug shops, bakeries filled with sweets made of shredded wheat and honey with names like "lady's navel" and "lips of the beloved," and went into a store whose windows were crowded with tiny coffee cups, jewelry, and *nargiles*. I scanned the merchandise with a

strong sense of déjà vu. I glanced at the sixtyish face of the man behind the counter. It was vaguely familiar—certainly Mediterranean, but not Turkish. When I pushed back the spiderwebs of memory, I realized that most of the physiognomies I'd seen in my childhood were like his.

"The store looks just like Uncle Fred's 'Fresco's Souvenirs,'" I murmured to my husband.

The man behind the counter suddenly looked at me keenly. He leaned forward and asked, "You said Fresco? What do you know of Fresco?"

"It was my maiden name," I answered, suddenly as keenly attentive as he. "Why do you ask?"

"Did you know a Moise Fresco?"

"He was my grandfather! My father's father! How did *you* know him?"

"I come from Istanbul. I'm a Sephardic Jew. And he was well-respected and known in the Sephardic community. I never actually met him—he was from another generation but he and his family were known to us. He had a son who went to South Africa—"

I interrupted him eagerly: "That was my Uncle James!"

"And an older son who went to America—" he continued, his words tumbling over mine.

"My father!" I was ecstatic. Here in Konya, in the core of Islam, I'd found an unlikely thread in my Sephardic tapestry.

Out came the tea. For the next hour the shopkeeper talked like a man starved for conversation—"There are very few of us in Konya—" about his family, my family, Sephardim in Turkey. The man absolutely refused to accept any money for the delicate bracelet I chose for my daughter. He pushed my purse aside and said adamantly, "How could I accept money from the granddaughter of Efendi Moise Fresco? Never! Take this bracelet, please; it would be an honor to give it to you."

As we were leaving, the man handed me a large blue glass bead—protection against the evil eye. "Even those who don't believe, believe in it. Who is to say this won't protect you?" We embraced each other like long-lost friends who had met again in a foreign land.

"Is no place for primitive belief in Turkey today!" was Ibrahim's fractious retort when we brought up the subject of Islamic fundamentalism later that afternoon. In a previous discussion of religions, he had established his credentials. He was a Turk and a Muslim; Anna was an Armenian and a Christian, none of which was of any importance. "The whole religion business doesn't matter at all. We love each other. Is enough."

In Konya, Ibrahim had been repelled and threatened by the intensity of the Sufic faith. The farther away we drove from this detested city, the more relaxed he became, until finally we reached the great high central plateau of Anatolia, Turkey's bread basket.

Small huddles of women in postures of bone-deep patience tilled the fields, bent over next to immobile donkeys. They ignored the jarring presence of bright yellow tractors that stood stationary in the fields, grants from a government that hoped to introduce modern methods of agriculture. The tractors were used, as far as we could see, only to transport the women to the fields.

In spite of a white sun that seared the earth, the women were swathed in layers of clothing—*salvars* (roomy Turkish pants), blouses, skirts, and sweaters. Scarves covered faces Tartar in origin, coarser and heavier than those we'd seen in Istanbul or along the coast.

The only breaks in the horizon were occasional clots of mud huts, almost invisible until one came up on them, their numbers hardly sufficient to constitute a hamlet. Added to the sense of an uninterrupted agrarian round in the severe wheat-colored

monotony of that landscape, they seemed beyond the confines of history.

I felt adrift in obliterated time. We might have been driving for an hour, or just as easily for a day, traveling back a millennium towards the cradle of civilization while traveling forward into empty distance.

It was here that Ibrahim chose to plug in a music tape. Acid rock with undertones of the nasal saz echoed out across the ancient plains. I felt disembodied! What was I *doing* in the middle of Anatolia, listening to twentieth-century cacophony in a heat fit only for mad dogs and Englishmen? What could this possibly tell me about my roots?

We were poring over our guidebooks in the back seat of the crammed Renault, convinced that Ibrahim's knowledge of Cappadocia would be abbreviated into "A TOUSAND YEARS!!" when a spectral landscape suddenly loomed up in front of us. But we were wrong about Ibrahim.

We had underestimated his love of Cappadocia. Its illusory nature corresponded perfectly to his romantic inclinations, and he knew its crevasses and vales as intimately as he knew the dictates of his own heart.

For the next three days Ibrahim was our impassioned guide through this area birthed during the Cenozoic era thirty million years ago by three active volcanos—Erciyes Dağ, Hasan Dağ, and Melendiz Dağ. Their continual eruptions over geologic time had covered the land with layers of tufa (compressed volcanic ash and basalt). Rain and erosion completed the process. The result was an eerie world painted from a palette of pink, muted ochre, and pistachio green, a world of cones and canyons and tall stone needles with rocks seemingly balanced on top, thrusting pinnacles hiding within them beehived caves—the stuff of dreams.

In this phantasmagoric landscape, a collision of religious

beliefs occurred during the eighth and the ninth centuries. It was here that Paul of Tarsus, bringing his message of redemption, had scant trouble converting the people to Christianity. A number of secret monastic complexes, some twenty stories deep, evolved here, tunneled down like ant colonies and hewn out of the shielding cliffs. In this way, medieval Christians fled underground from Arab, Persian, and Tartar marauders, and lived and worshipped in safety for over a hundred years.

Hidden churches, masquerading as simple houses with innocent-looking entrances in the area of Göreme, crouched behind benign-looking entrances, could be reached only by climbing up a series of wobbly wooden ladders.

Once inside, we were mesmerized. In the Church of the Buckle, one of the most famous in the area, we were startled by brilliant ninth-century Byzantine murals, almost contemporary in their simplicity, depicting the lives of St. Basil, Virgin Mary, and the Apostles.

What sort of paint did they use in those days, I asked Ibrahim. He just shook his head. What kept those radiant colors from fading, the protective coolness inside the caves? He didn't know. He simply stood and stared at the murals, incredulous, although he had been there many times before. He, so adamantly secular, a child of Atatürk's Turkey, was transformed into a believer.

How I wished my mother could have been there! She would have connected immediately to the 2,000-year-old story. I used to think it was due to a quirky throw of the genetic dice that my mother had been born into a Sephardic family rather than a Christian one, preferably Catholic. It would have better suited her spiritual nature and saved her from the life-long anguish she felt as one temperamentally isolated from her family and times. But the choice wasn't hers.

Judith's Folly

SOMETIME WHILE IN MY forties and still struggling to come to terms with my mother—and myself—I tried to get some perspective on her character. I began to write the story of her life, or as much of it as I know, in the first person, as though she, Judith, were telling it. I drew from the tales I'd heard from her, or from my Aunt Fortunée. By subduing my own voice, I found I got closer to the bone. "I was born into a family of nine children...."

It proved to be a fascinating exercise. What emerged was a portrait of someone who appeared to have the same fully realized characteristics in her earliest years as those that defined her the rest of her life. This portrait went a good way toward answering my tacit question, "Was she ever thus?" What if this serious, orderly, sensitive, moral child had been born into another family? Nature? Nurture? I tended toward the former.

In a family of strong, demanding personalities, squeaky wheels all, she made no fuss, sought no special favors, and that in itself made her different from her siblings. But she must have felt a lack, because she recalled asking her mother, "Mamica, why don't you pay more attention to me?" Her mother put her arms around her and sighed, "My poor child, can you understand what it is to have nine children? And *these* children!"

As a girl of nine, my mother asked her six brothers if they

would allow her to keep their clothes drawers in order. They said yes, of course, glad to be rid of a boring task. As a girl of twelve, she suggested to her schoolmates that they form a club "to do good deeds." She who did best would receive the prize of a pansy at the end of the month. I could imagine their response, and felt a pang of rejection for her when she told me the story. It became a club composed of two members, my mother and her best friend. Bringing order and doing good became the leitmotifs of her life.

When my mother met a thirty-five-year-old suitor from America, she was a plain-looking twenty-seven-year-old principal of a small school, with no visible prospect for marriage, unlike her younger sister, Fortunée, whose outgoing personality and rosy beauty attracted a string of interested men, all of whom she rejected as unworthy.

The unexpected appearance of this suitable man must have seemed like a miracle. Small wonder, that radiant smile in the photograph of her and my father before their marriage. The reality turned out to be a new world, a new language, and an alien society. She brought to this new life her diligence. But I always sensed that beneath the dignified matron another woman existed, dedicated to the intellect and the spirit.

Every week for five years, beginning when I was about ten, she would meet with her best friend who shared her two passions, reading and exploring the essence of morality. Out came the hand-embroidered cloth, out came the tea and biscuits and the books. I would sit in a corner of the living room, ostensibly drawing but watching covertly as my plain mother became an animated woman, her color heightened by happiness in communicating with a kindred soul. At these times, she was almost beautiful.

Her safe and orderly world collapsed when my father died. She found herself with a miniscule insurance policy (a case of the shoemaker's daughter), a fifteen-year-old daughter to support, no

work experience in this country, and no home—we had lost our house several years before because of late mortgage payments, and now lived in an apartment. Her coping system broke down. In the parlance of the day this was referred to as a "nervous break-down," an expression uttered in hushed tones that always left me with the vague impression of something shameful.

Three months in the kindly, undemanding atmosphere of a Seventh-Day Adventist sanitarium restored her balance, and she returned to me, a new apartment, and the only available work—sewing piece-work, at minimum wage in a sunless factory. I heard no complaints. She continued to maintain a well-run household for the two of us. But her pain was tangible to me.

I was fifteen at the time, and I transferred my unexpressed grief for my father to a fierce protection of my mother. If I couldn't bring him back, at least I would cause her no trouble. I would be her ally. I would make her laugh. And I did, although I think that what really saved her was her natural discipline, doubtless augmented by her Catholic school years. And, always, she retreated into her beloved books. But there was a void in her life: she was a vessel waiting to be filled.

That void was filled in my eighteenth year, in the form of one Mrs. Gilman, to whom my mother had been introduced by a mutual friend who thought the two women would form a sympathet-ic bond. Ruth Gilman was a powerful, handsome New England woman of considerable means, in her sixties, whose husband, daughter, and son had been killed in a boating accident, and who claimed to communicate with spirits "on the other side." She needed a companion.

My mother was ripe. She was needed. She could bring order into this new household, and she was more than ready to adopt her new friend's beliefs. Thus began a ten-year association with "that woman," which is what the family called Mrs. Gilman,

whom they looked upon with grave suspicion. She was shameless-
ly using my mother, and mother, *"la pauvre Judith"* (poor Judith),
with her quirky ideas, was allowing herself to be led even further
into murky spiritual waters.

They did use each other, and for several years both benefited
from the arrangement. My mother spent more and more time
with Mrs. Gilman until, when I was twenty and self-sufficient, she
moved out of our apartment to live with Mrs. Gilman during the
week, coming home only on weekends.

Enter Walter, Mrs. Gilman's long-time bicoastal lover. Mar-
ried (his wife in the East), a stately and somber man fifteen years
younger than Mrs. Gilman, he shared her belief in that other spir-
it world. He arrived from New England and stayed for six months.

Their spiritualist activities accelerated. Walter and Mrs. Gil-
man professed a strong urge to write a book, one that would be
dictated by guides from the other side, a book that would contain
the wisdom of deceased leaders such as Franklin Roosevelt and
Henry Ford about present conditions in the world and what
would befall it unless certain steps were taken to prevent disas-
ter—steps outlined in the book, of course.

At last my mother was involved in a project bigger than her, a
project to do good, to bring order to the world. Every morning
Walter would sit at the typewriter; Mrs. Gilman sat at his elbow,
asking questions of the "guide." He would type the answers—au-
tomatically, he claimed.

My mother, Alice B. Toklas (she even looked a little like her!)
to Mrs. Gilman's Gertrude Stein, hovered about, fascinated,
bringing meals, running the household. Their hours were long,
exhausting, and completely absorbing. Finally, the book was
finished. Time to launch it.

The three pilgrims left for New York, buoyed by great hopes
and a positive response from E.P. Dutton Publishers. They head-

quartered in a midtown Manhattan hotel for three months. But Dutton had second thoughts. The pilgrims sought other publishers, but to no avail, and finally New England common sense took over. Mrs. Gilman and Walter came to the conclusion that the book was not publishable—at least for now—put it to bed and headed home.

But not my mother. The publication of the book became her *raison d'être*. She was convinced the message it contained was of primary importance, and her obdurate belief eventually caused a permanent rift between her and Mrs. Gilman. But for the rest of my mother's life, she hoped the book would be her gift to the world.

Finally, alienated from the rest of the family by the strength of her obsession—yet again, Judith's folly—she made a pilgrimage to Washington, D.C. The president of the United States must be advised! She had made no hotel reservations beforehand, certain that God would provide, which He/She did when she showed up, unannounced, at the Turkish Embassy.

"I am the daughter of David Fresco, and I am here on very important business with President Eisenhower. As a former Turkish citizen, I am certain that you will be kind enough to find me a suitable hotel at diplomatic rates."

They obliged. Did they know who David Fresco was? I doubt it. Perhaps they were intrigued by the imperative appearance of this distinguished-looking woman dressed entirely in black, who spoke with a French accent. The following morning she went up to the gate of the White House, where she presented her manuscript to the polite man who barred her way.

"My name is Mrs. Fresco. It is of utmost importance that the president see this book."

"The president is extremely busy at the moment, madame, but if you give me the book—and your address—I'll certainly see

to it that he gets it," said the man, who was undoubtedly trained to deal with all manner of crackpots, including elegant older women with foreign accents.

She turned the manuscript over, unprotesting, and for the next two days wandered happily through the museums of her adopted country's capitol. On the third day, two unsmiling men dressed in governmental gray showed up at her hotel, the manuscript in hand. They informed my mother that while the president was certainly intrigued by the book, he was currently so busy with other concerns that the time was not ripe for consideration of its message. Perhaps in several years....

The men politely but firmly suggested that my mother leave town. She did, counting the pilgrimage not as a failure, but "not the right time." *Inshallah.*

Over the years she sporadically continued to try to convince people with political power to read the book. There was a four-month stay in Arizona, where she unsuccessfully attempted to contact Barry Goldwater. Amazingly, she made it through the bureaucratic maze up to Goldwater's second-in-command. While waiting for the interview that never came, she spent her time getting to know the desert and its flora. I have a notebook she made of exquisite drawings of cacti, replete with Latin names, and a history of Arizona compiled from brochures and books from the local library, under the guidance of a librarian who wrote me to state her admiration of "your extraordinary mother," whom she dubbed a true anthropologist.

Throughout all these years, although I never could bring myself to read the book, I maintained a neutral stance. I didn't share her belief that the book was written "from the other side." I felt it was written out of Mrs. Gilman's and Walter's psychological needs, of which I knew nothing, and out of a profound need on my mother's part to be connected with something larger than herself. Her

attitude was not unlike that of uncomplaining missionaries who tolerate frequent rejection as part of a consecrated calling.

So while "Judith's Folly" was rejected by the family, I knew it was the glue that held her together, and refused to add my voice to theirs, if only out of loyalty to her. But in private, I could be plunged into a maelstrom of feelings composed of embarrassment and anger when, meeting someone new, she indulged her maddening habit of riveting her eyes onto the person's face and asking, in a sepulcral tone, "Do you believe in God?"

From time to time another obsession, like an illness that had been in remission, resurfaced. During a particularly low period, her suffering from family rejection manifested itself metaphorically in her absolute conviction that she bore stigmata.

"Look at my feet! Look at my hands!"

She saw the marks. No one else saw them. But my Uncle Fred's wife, Aunt Arloa, offered her house on Catalina Island and a nonjudgmental heart. After three months of such kindness, my mother was "cured."

As she grew older, Mother's active attempts to have the book published subsided, but her faith in it never wavered. Shortly before she died, she offered the manuscript to my husband and me. We took it, of course, but didn't read it for some twenty years.

When enough time had elapsed that we could pick it up with equanimity, we did read it. Maybe in some corner of my mind, I expected to find, against all odds, revelations. Instead, I found the book to be repetitive, unoriginal, and simplistic. It made me sad that so much passionate good will had been expended on such a guileless tract. To my mind, it represented her painful divorce from the "real" world, her repeated rejections. But that was my view. In hers, this was "God's work." And she never questioned it.

So, standing now in a cave in Cappadocia twenty-five years later, I was certain that had my mother lived here during the time

of Paul of Tarsus, she would surely have become one of his converts, as did the medieval Christians who had fled to Derinkuyu in the middle of Cappadocia.

Derinkuyu was one of the underground cities in the south of Nevşehir, a depressingly ugly town defined by concrete. Derinkuyu descended five floors and was one of only three cities that had been partially excavated and opened to the public. Ibrahim took us there. No other tourists were present that day, only the three of us. Anna opted to stay outside.

We entered a maze of tunnels that had once been a city—two or three thousand fugitives could have lived here—occupied mostly by Christians. I assumed that forebears had built these tunnels. Romans? Certainly, claimed the books. Or Hittites, as proven by stone tools. The facts were lost in time.

We slithered one at a time past a giant round blocking stone near the entrance, meant to seal off the enemy, into a world of silence and coolness, and hunkered down through a nightmare of a low-ceilinged tunnel, with slits in the wall for thrusting spears at any unfortunate who had the temerity to enter this defensive bastion. Crudely drawn arrows pointed the way to sleeping rooms, mills, baptisteries, graveyards, and communal kitchens. Water came from underground springs, air from an elaborate ventilation system above. It was a completely self-contained community.

What if I accidentally took the wrong turn and lost my way in this world more suited to troglodytes than tourists? What if the casually strung light bulbs suddenly went out? They don't last forever, and who knew how long they would stay lit? What if...?

My overriding curiosity was accompanied by a thrumming dread, which abated only when we emerged into blinding sunlight and an encampment of Gypsies. They had planted themselves across from, but not in competition with, the predictable rug dealers outside the caves.

One particularly venomous-looking woman, a scrawny babe suckling her withered teat, wore silver bangles all the way up her bony, sooty arms.

She pointed to my purse. I opened it and handed her a fistful of lira. She grasped it, and a sound like an angry gargle spewed from her mouth; then she made a quick clawing motion as if to jerk the purse away from me. I could almost see a sizzling voltage surrounding her. I jumped back, frightened, and ran to the car, tripping over a chicken that scratched in the inhospitable dirt.

A savagery hovered in the air, the historical savagery that had driven people to dig themselves deep into the bowels of the earth because of fear, as well the hostility I felt from the Gypsy, who saw me not in human terms but simply as an object to exploit. This feeling was in such contrast to the deep kindness I had experienced so far, that I couldn't put it in context. I momentarily forgot that while the kindness existed, so did a lengthy history of barbarous exterminations, invasions, and violent pillages from conquerors too numerous to list, both from within and without the country. But when I calmed down and considered the experience, it seemed amazing that a culture of such legendary hospitality had managed to survive the cataclysmic events in its history.

That small incident left me suddenly anxious to get back to the familiar crowded, schizophrenic, history-laden city of Istanbul. By some strange alchemy, it felt like home. I wanted badly to see my family. And this time I was resolved to see the house on Büyücada; there wouldn't be another chance.

The House

FROM CAPPADOCIA it was a straight shot to Ankara. The city, though faultily planned, mired in a network of highways, and the victim of terrible smog, nevertheless had to be reckoned with for a number of reasons. It was Atatürk's choice for his new capital—connected to the plains of Anatolia, and, most importantly, far removed from the layered intrigues of its rival, Istanbul.

Here was the Grand National Assembly—the Turkish parliament. Here were the embassies and governmental and business districts that owed little obeisance to Istanbul. Though Emile lived in Istanbul, it was to Ankara that he came at least twice a week to conduct national and international business.

We had come to visit the anthropological jewel in Ankara's crown, and it was worth the stop. The small Anatolian Civilizations Museum contained dazzling displays, beginning with the neolithic period, and continuing through early castings of the Bronze Age, the famous antlered deers of the Hittites, the Phrygian and Urartian periods, and the Greek colonization—a whole span of civilizations in only three large rooms.

Ibrahim, Anna, my husband, and I had a last dinner together at an elaborate wooden house turned restaurant near the old citadel on the hill, where the soft violet light of early evening hid the stark ugliness of Ankara. After dinner, Ibrahim drove us to the

train station and deposited us on the overnight Orient Express to Istanbul. To our utter astonishment, Anna, who had been silent the whole time except for *soto voce* murmurings in Turkish, gave us a warm hug and said in English, "Have a good trip." We stared at her. Had Ibrahim taught her this one phrase, or had she known English all along? Or had he put one over the tour company and sneaked her along—strictly taboo—with the admonitions that she remain silent? I think the latter. Ibrahim had the grace to blush. Then all of us burst out laughing.

Once I am berthed and horizontal, I am usually lulled to sleep by the hypnotic clickety-clack of a train. But this night I couldn't sleep. I was about to leave a land that had profoundly engaged my heart and seduced me into another sense of time, and I wasn't sure I would ever see it again.

My mother was twenty-seven years old in 1920, when she left Turkey for America as a new bride. Had she felt bereft? Did she wonder if she would ever return? She never did, in fact. Instead, she maintained a mental scrapbook that she opened increasingly often as she grew older. The facts, or perhaps they were legends, acquired a burnished quality, much like the tales of Irish storytellers—the objects of continual polish and refinement. My father, at seventeen, had probably left his homeland with fewer attachments. But would I ever really know that?

All along I had nurtured the fantasy that a *haç* to the house on Büyükada would leave me wiser, somehow, about my father. But now there were only two days left. I called Nevzat as soon as we arrived in Istanbul the next morning.

"We leave tomorrow and I *cannot* go without seeing the house on Büyükada."

In typical Turkish fashion, Nevzat dropped everything and came by cab to fetch us at our hotel, and plunged into the automotive maelstrom that ended at the ferry station near the Galata

Bridge. A fleet of large white motor launches draped with orange lifesavers were lined up, four by four. We boarded the *Bostanci* and went topside to survey the scene.

It was a beehive of maritime activity. Ships of all sizes plied the oil-drenched waters of the Bosphorus—huge passenger liners, Russian tankers with black diesel fuel erupting from their slanted funnels, American warships in military gray, and a mini-armada of crisscrossing ferryboats and fishing trawlers. Darting around and about the others were the descendants of the old *kayic* taking for granted their inalienable right to share the water.

We sat on straight white benches among somberly dressed women and their children and a silent group of men fingering their worry beads. All of them stared at me with polite curiosity. I gazed back, smiled, and said, *"Merhaba."* They smiled back and returned my greeting. White-jacketed boys carrying aluminum trays hawked their wares.

"Colabirraçayçayçay!" Cola, beer, tea, tea, tea!

Without hope, an old man went up and down the rows of benches holding out lottery tickets. Without hope, Nevzat bought one.

"I never win," he mused, no rancor in his voice.

"Why do you buy them?"

"He has to make a living," was the answer.

We turned into the Sea of Marmara and crossed over to the Asian side and docked briefly at the bustling city of Haydarpaşa, where my mother's family had once lived, to drop off passengers and pick up others going on to the Princes Islands.

There are nine islands in all, of which only four are presently inhabited. Kinaliada appeared first, then Burgazadiasi, then Heybeliada, and finally the largest and farthest away, Büyükada (Big Island), known to the Greeks as Prinkipo.

About 80 percent forest, inviting and benign to the uninitiated

tourist eye, the island nevertheless has a bloody, piratical history, beginning with the Empress Irene. Having dethroned Emperor Constantine, she herself was later dethroned and exiled to Büyükada.

The Venetians, the Russians, and the Romans all in their turn raided and plundered the island. In 1453 it became one more possession of the Ottoman Empire. From then on, Büyükada was the place of exile for disgraced politicians and other governmental embarrassments. The twentieth century added yet another chapter to the island's political history in 1929, when Leon Trotsky, banished from the Soviet Union and refused admission to other countries, was granted asylum by Turkey and lived on Büyükada for the next four years.

Today, domesticated and tranquil, Büyükada claims a steady population of 5,200, which swells with 2,000 excursionists during the months of June, July, and August. But even with the boatloads of Istanbullu who come over during the summer months to populate the beaches or stroll in the cluster pine forest, the absence of cars on the island determines its leisurely pace. One either walks or takes a phaeton.

We watched the island loom into view, bulky and green, a benign behemoth afloat in the Sea of Marmara. Like a beckoning finger, a long jutting pier invited visitors through a large pavilion and into its heart, the town circle that served as axle to the ancillary streets lined with shops, cafés, and hotels.

It was in late September, and yet people lolled on the grass or sat leisurely at cafés and watched passengers disembark in the sultry little port. Officially, summer was over, the national elections were only a week away. Rows and rows of tiny fluttering colored flags had been strung from lamppost to lamppost along the streets. Although their purpose was to exhort the populace to vote for so-and-so, the overall feeling was one of some winsome provincial Italian town preparing for the local carnival.

We walked down one of the streets to a plaza where all the phaetons were gathered, some twenty in all. A collection of blink-ered horses in varying states of health laconically swished their tails while their owners motioned us over to examine the animals and carriages. Nevzat decided on a carriage drawn by two docile horses and driven by a local with two prominent silver teeth in one side of his mouth and a sweet face weighted with sadness. They negotiated for the *"küçük tur"* (short tour), which began at the quay and went through the middle of the island, looping up through the forest, then along the other side and back into town.

In an incomparable swaying, buoyant motion, we slowly clat-tered up through palm-lined streets. Three- and four-storied villas were set back on spacious lawns, embellished with fretwork over-hangs and balconies reminiscent of Victorian whimsy—houses of consequence, built for generations of leisurely living in a felici-tous climate. The scented gardens were riots of roses, hydrangeas, trumpet vines, and morning glories with long ancestries.

We wove through the forest to a clearing area where the driv-ers traditionally stopped to give their horses a rest. A little café of-fered the usual soft drinks, tea, and coffee. Solitary, untethered horses wandered through the pines and nuzzled the grass or stood like mottled statues in the filtered light. Then we began a leisure-ly descent along the other side of the island, back again toward the houses.

Nevzat said something to our driver, who shook his head and looked even sadder than before.

"He doesn't think the horses can make the grade up the street to the house, it's too steep. Isn't it ironic? Aunt Nouriye used to walk down this hill to the port and back up again every day—and at the age of *eighty*! But these poor horses.... Never mind. We'll take the phaeton as far as we can, then we'll have to walk the rest of the way up."

We turned up a precipitous cobbled street. The horses valiantly pulled and panted and snorted about a quarter of the way up, urged forward by the worn whip and muttered oaths of the sad driver, then stopped altogether. We got out of the carriage and walked the rest of the way to the top, and at last I saw it—the house that had sheltered several generations of my paternal family.

Three years earlier, Aunt Nouriye, the last occupant, had locked the door, deposited the key with her nephew, and moved away to Israel, leaving the two-story gray stone edifice, a solid, unpretentious house of honest proportions. The narrow garden in front was now covered with the debris of rotten wood fallen from the roof. We stepped over it gingerly, then Nevzat put an ancient key into the door, and we entered.

The house had been thoroughly ransacked. Nevzat had prepared me for an old house in bad condition: "Remember, it hasn't been used in years." But none of us was prepared for the unexpected plunder. I heard Nevzat draw in his breath, then he shook his head from side to side.

The rooms had been almost completely stripped. What little furniture remained—a heavy wooden table in the middle of the living room, a tall cabinet probably too massive to move—was covered with fallen wood and dust. The chairs, the tables, the lamps, the drapes—all had been taken.

A jumble of letters and photographs lay scattered on the floor. I leaned down, picked up a yellowed photograph with curling edges, and turned it over. It was a photo of my mother and me at my daughter's wedding in California twenty years ago!

We got down on our knees on the littered floor and began scrambling about for more photographs. The faded faces of cousins and uncles appeared, and scenes of picnics on the beach, gatherings around large tables for apparently celebratory meals, and more.

Everything was out of context. I felt as though I had accidentally stumbled into a surrealist landscape.

We climbed up to the second floor—"watch the steps, you might fall through!"—to four bedrooms off a central hall. All but one bed was gone. The spectacular view of the Sea of Marmara that Nevzat recalled was now completely obscured by the third floor of a newly built house next door, nonexistent three years ago.

We crept up to the large attic. Four antiquated steamer trunks, their cracked leather peeling, had been pried open, their contents rifled through and strewn carelessly about, obviously useless to rummagers looking for saleable items. We carefully picked through letters from family and friends announcing weddings, births, and deaths, the urgency of their news now reduced to faded ink.

Piano music was scattered about. Aunt Nouriye, "the musical one," had given piano lessons to eke out a modest living. I picked up a piece of sheet music and dusted it off. On the cover of *L'étoile du Bosphore* (Star of the Bosphorus), a waltz of saccharine inclinations, was the picture of a languid Oriental beauty, her turbaned servant in attendance, domes and minarets in the background.

We went back down into what remained of the kitchen, now just a square room dominated by a large hole in the ground. "There was a cistern here once," said Nevzat. "Grandmother used to fall in once a year, like clockwork; one of us would have to rescue her." He smiled wryly. "Maybe it was the glass of sherry she drank every evening." I wished I had one now, to toast this animated, independent woman who had lived into her nineties and unknowingly outlived her son.

We wandered through the house again and again, putting papers neatly in piles—it seemed a sacrilege to leave them

scattered—looking for what exactly, we weren't sure. I know that I simply didn't want to leave. Then, in a final search, I pulled open a drawer of the cabinet and saw a large sepia photograph, taken in America, of my father, with that familiar half-smile, in the full flower of his strength and youth.

I stared and stared at that picture. It had been taken at a time when he radiated confidence and optimism. I wrapped it up carefully and took it with me. I knew exactly on which wall of my house it would hang.

The patient horses were waiting at the bottom of the street. We rode slowly and silently back to the center of town. While waiting for the boat to arrive, we sat at a café and sipped several glasses of tea.

"What do you suppose it would take…?" I began.

"It would take a deed, first of all," said Nevzat, "and no one seems to know where it is, the house was acquired so long ago. Then we would need the birth certificates of both grandparents in order to prove ownership, and those have disappeared too. The other way would be to 'buy' a deed. It's done all the time.

"But assuming all of that is possible, the house the way it is now would have to be gutted, new plumbing and electricity put in, a new floor, a new roof. It would be a *huge* project—a year, at least. And someone would have to be here to oversee the work. The only ones living in Istanbul are me and Berto, and we already work fourteen hours a day. Even if we all chipped in, who has the year to devote to it?"

We counted inheritors. The remaining seventeen were scattered throughout the United States, France, South Africa, Israel, Turkey, Canada, and New Zealand. The prospect was dim.

"And so what will happen?"

"Someone from the provinces will probably 'buy' a deed, fix it up, move in, and live there or rent it out. Nothing really goes to

waste in Turkey. It is converted, or built over, or expanded, or turned into something else," Nevzat said.

I watched him slide effortlessly, unconsciously, into an Oriental state of mind.

We hardly spoke on the trip back to Istanbul; Nevzat and I were each enclosed in our own envelope of thought. Seeing the house had stirred up old memories for him. He had spent almost every summer there, as well as his honeymoon.

As for me, the idea of simply letting go of land and property seemed unnatural, wicked almost, from my point of view. On the other hand, reality decreed that my living some seven thousand miles away from this island in the Sea of Marmara made it impossible for me to take an active role in trying to save the house on Büyükada.

It was dusk as we approached Istanbul from the sea. The pewter haze that strangled the city during the day had turned into a polished saffron that silhouetted the domes and minarets of old Stamboul against the sky and returned the city to its Byzantine self, the twentieth century reabsorbed into the enigma of the East.

Seeing it so, I once again realized that somehow over the period of a month I had found a balance between the compelling fatalism that had governed my youth and the western pragmatism I later adopted. The dichotomy of these two opposing views had somehow been distilled into a state of peaceful coexistence. I felt no need to embrace one to the exclusion of the other. And so on this day, about to return to the West, I concluded that if the house on Büyükada was meant to remain in the family, it would. If not, it wouldn't.

Epilogue

THE PHOTOGRAPH of my father hangs on the wall of our library, beneath the photograph of his father. Beneath those is the medal given this grandfather by the sultan, and beneath that is a photograph of my six maternal uncles. And beneath all *those* are my mother's inlaid silver bath slippers. A Turkish shrine, if you will.

They give me pleasure, these objects. They provide me with a strong sense of continuity, a connection to a history that had previously eluded me. And they represent, finally, a completion to the search for my father's history.

Like the silent stones of Ilium, the walls of the house on Büyükada refused to disclose their secrets. But I finally realized that even though my father's earliest years were spent in the shelter of a Judeo-Turkish household, it was in another country that he lived out his promise, his failures, and his dreams—dreams about which I could only conjecture.

My conjecture will remain just that. He is buried in half-remembered truths—the bricolage of family legend, on top of which often-told but unexamined tales have been added. Other peoples' memories of the past, perhaps based on facts, perhaps not, are additional threads woven into the whole fabric. Now I, too, would add to this *höyük* (mound) of his total existence—my own interpretation of his life.

As for Turkey, I ended by perceiving the country not by hard facts; it's too complex, too ancient for simple answers—Jenny was right. Rather, I perceived Turkey through the process of absorption.

And I have made myself a promise: I will go back to Turkey one day—*inshallah*.